GIOVANNA FRANCI, ROSELLA MANGARONI, ESTHER ZAGO

A JOURNEY THROUGH AMERICAN ART DECO

Architecture, Design, and Cinema in the Twenties and Thirties

Photographs by Federico Zignani

UNIVERSITY OF WASHINGTON PRESS
SEATTLE

Published in the United States of America
by the UNIVERSITY OF WASHINGTON PRESS
P.O. Box 50096, Seattle, WA 98145-5096
Phone 206/543-4050 - Fax 206/543-3932

Library of Congress Catalog Card Number 97-60536
ISBN 0-295-97653-5

Published simultaneously in Italy by ALINEA EDITRICE,
50144 Firenze, Via Pierluigi da Palestrina, 17/19rosso
Tel. 055/333428 - Fax 055/331013
ISBN 88-8125-138-8

English translation: by Michael Serwatka and Charlotte Smokler

Special thanks for the financial support to:

FONDAZIONE CASSA DI RISPARMIO in Bologna
UNIVERSITY OF BOLOGNA, Department of Foreign Languages
NATIONAL COUNCIL FOR RESEARCH (CNR)
ITALIAN MINISTRY OF EDUCATION (MURST)

Cover illustration (front): New York, Chrysler Bldg., detail
Cover illustration (back): Los Angeles, L.A. Branch Federal Reserve Bank of San Francisco, detail

Printed in Italy, February 1998

Photocomposition and photolith: B.M. s.r.l. - Castenaso - (Bologna) http: www.BM.it
Printed by: Tipografia Babina - S. Lazzaro (Bologna)

Acknowledgments

Our sincere gratitude to the many - friends and colleagues, scholars and collectors, librarians and representatives of institutions, archives, firms and properties - who provided precious material, ready assistance and information in the compilation of this book.

Particular thanks to: Arizona Biltmore Public Relations Office (Beth E. Hasselbach and Leslie A. Tweeton); Architecture and Urban Planning Library, University of Washington; Art Library, UCLA; Jean Ashton (Director, Rare Book and Manuscript Library, Columbia University); Jeanne and Harold Bloom; Jane and Marshall Brown; Gwynedd Cannad (Curator, Urban Collection, Columbia University); Cesare Cesarini; Cineteca del Comune di Bologna (Roberto Benati, Paolo Pasqualini, Angela Tromellini); Gianfranco Civolani; Alessandra di Luzio; Consuelo and Dennis Dutschke; Norma and Todd Ewalt; Antonio Faeti; Gabriele Franci; Bernie Frischer; Mitchell Gershenfeld (Executive Director, Historic Paramount Foundation, Denver); Giulia Guarnieri; Giovanni Guasina; Miriam Hansen; Wendy Hester; Priscilla and Michael Heim; Thomas S. Hines; Susan Lanman Wellhofer; Franco La Polla; Library of the University of Colorado at Boulder; Alberto Manguel; Franco Minganti; Barb O' Malley (Manager, Cruise Room Bar, Oxford Hotel Denver); Piero Narcisi (Biblioteca Dip. Arti Visive, Università di Bologna); Paola Pallottino; Giancarlo Piretti; Stefano Pompei; Steven Ricci; John Paul Russo; Antonella Savioli; Albert Sbragia; Gino Scatasta; Vittoria Toschi Rinaldi; Ugo Volli.

Credits

All the photographs, unless otherwise credited (see below, *), have been taken especially for this book by Federico Zignani.

Architectural Digest (Mary E. Nichols, Photographer), (in color: p. 44);
Archivio fotografico, Cineteca del Comune di Bologna (in.b/w: pp. 10, 11, 12, 13, 21, 26, 27, 28, 29, 30; in color: p. 43);
Chicago Historical Society, Prints and Photography Department (in b/w p. 9, photo by Raymond Trowbridge; p. 33, by Hedrich-Blessing; p. 33, by Kaufmann and Fabry; p. 34, by Raymond Trowbridge; p. 35, by Raymond Trowbridge);
Norma and Todd Ewalt Collection, Longmont, Colorado (in b/w: pp. 19, 32);
Historic Paramount Foundation, Denver (in color p. 44);
Rare Book and Manuscript Library, Urban Collection, Columbia University, New York (in b/w: p. 18; in color: p. 38);
Gino Scatasta Collection, Ascoli Piceno (in b/w: p. 23).

Photographer's Acknowledgments

For their cooperation and kindness I thank all the people who made the publication of my photographs possible. In *New York*: William Bassnett (Chrysler Properties Inc.); Richard D'Angelo (Tishman Speyer Properties, Rockefeller Center); Phil DeCapua (Shorenstein Company); Steven M. Durels (Helmsley-Noyes Co., Inc.); Paul Greene (Chanin Building); John Meyjes (Lou Hammond and Associates, Waldorf-Astoria); Lydia Ruth (Helmsley-Spear, Inc., Empire State Building); Harvey S. Rifkin (Silverstein Properties, Lefcourt National Building); John Silbertein (Senior Vice President, Mendik Company, G. E. Bldg:). In *Denver*: David Beigie (US West Communications); Roberta Cation (940 Bonnie Brae Blvd:); Mitchell Gershenfeld (Historic Paramount Foundation); Barb O' Malley (Cruise Room Bar, Oxford Hotel); Paul S. Richardson (Landmark Theatre Corporation, Los Angeles, Mayan Theatre in Denver). In *Boulder*: Susan M. Ashcraft (Deputy County Commissioners, Boulder County Court House); Shawn Axelrod (Manager, Boulder Theater). In *Phoenix*: Leslie A. Tweeton, Beth E. Hasselbach (Arizona Biltmore), and Mary E. Nichols. In *Seattle*: Robert Bensussen (Morris Piha Management Group, Inc.); Michael J. Dierdorff and Loretta Alake (Seattle Tower and Olympic Tower); Betty Joe Kane (Suzzallo Library, University of Washington); Darren Williams (Exchange Building). In *Los Angeles*: Al Bobier and Sunny Ahn (Selig Bldg.); Donald and Lisa Barr (LA Jewelry Center); Eugene and Lisa Baur (Park Plaza Hotel); Medhi Bolour (Eastern Columbia Bldg.); Vanessa Butler (P.R. Hollywood Bowl); Sammy Chao (L.M. Mayan Theater); Sally Childs and The Citadel; Francine Della Catena (Los Angeles Times Bldg.); Frank De Pietro and Sons (Vine Tower Bldg.); Daniel Griesmer and Cecily Foster (Mann's Chinese Theatre); Anna Gross and The Cecchi Gori Group; Dr. E. C. Krupp (Director, Griffith Observatory); Mr. La Krentz (Crossroads of the World); Maurice and Suzie Mazur (Sowden House); John A. Mc Carthy and The Summit Group (Title and Guarantee Bldg.); Kristina Morita and David Haut (P.R. Dept. The Central Library of the LA Public Library); Tony M. Morris (LA Branch Federal Reserve Bank of San Francisco); Rodney Nardi (El Rey Theatre); Robert W. Phillips and Rosemary Schlagaer (L.M. Coca Cola Bottling Co.); Moussa Shaaya (Desmonds Bldg.); Leslie Steinberg (P.R. South Western University School of Law Library/Bullock's Wilshire); Melissa Volpert (The Argyle Hotel); Amy Wood (E.R. Pacific Crest Theatre). In *Miami Beach*: Joanne Bretzer (Helen Mart Apts:); Nadia Damati (Abbey Hotel); Ian Innocent (Marlin Hotel); Jonas Haeger (Beacon Hotel); Steven Schnitzer (11st St. Diner); and all those who I might have forgotten

Special acknowledgments go to Jane and Marshall Brown, Consuelo Dutschke, and John Paul Russo for their help, hospitality and kindness, and extra special thanks to Ruby O' Campo for her encouragement and inspiration.

Finally, I dedicate my photographs to my parents, without whose support this book couldn't have been possible.

Federico Zignani

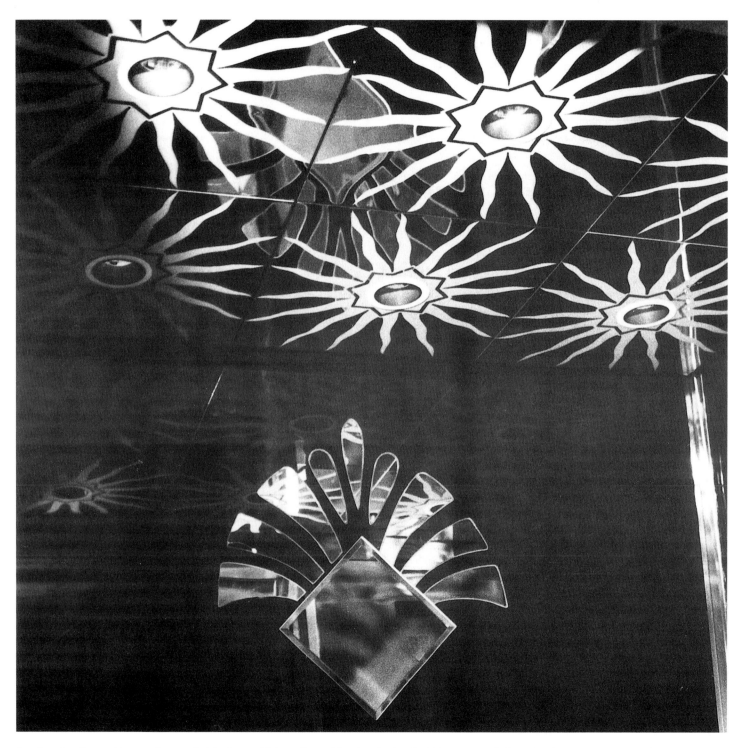

Los Angeles, Sunset Towers (later called St. James Club, and now The Argyle Hotel), 8358 Sunset Blvd., (Leland A. Bryant, 1929), elevator-interior.

CONTENTS

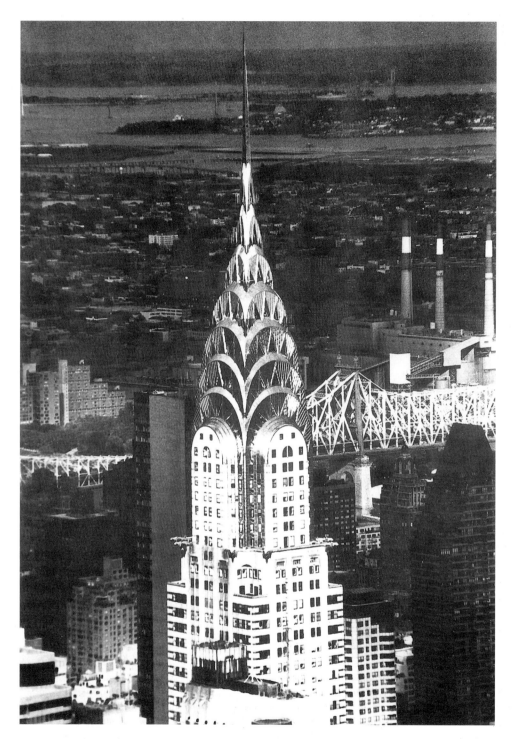

New York, Chrysler Building, 405 Lexington Ave. at 42nd St. (W. Van Alen, 1928-30).

IN SEARCH OF AMERICAN DECO

"America needs the flamboyant to save her soul-said Vachel Lindsay to the indifferent mountains....Jazz, the Follies, the flapper in orange and green gown and war-paint of rouge-impossible frenzies of color in a world that refuses to be drab."

William Carlos Williams

"And it all seems rosy and romantic to us who were young then, because we will never feel quite so intensely about our surroundings any more."

F. Scott Fitzgerald

This book, which can be considered a series of entries in a travel diary, appears, by felicitous coincidence, on the occasion of the first centenary of cinema.

A few years ago, we mapped out an itinerary which took us from the ancient and mythical Byzantium to what we playfully called Byzantium's other shore, that is, Disneyland, a place just as mythical, created in our own times by an astute mixture of fantasy and technology. Now, however, we wish to go on a journey of exploration which, starting from cinema and ending in cinema, takes us not only through theatrical and cinematic space, but also through the grand spectacle of the American cityscape, dominated by that great American invention, the skyscraper. This will be a fanciful and not too systematic voyage into that special world which was Art Deco during the Roaring Twenties, the depression years, and the New Deal. We will be visiting a number of cities which contain some of the most interesting surviving examples of the art and the society of that period in the United States: Chicago, New York, Seattle, Los Angeles, Denver, Phoenix, and Miami.

However, before going any further, it would be well to warn the reader about the broad and free use we will make of the terms "Art Deco" and "Deco," which in any case are of recent origin, having been coined (as will be discussed later) only in the late sixties. During the period we will be concerned with, various terms were in use. The European terminology was more categorical and precise, distinguishing between modern and modernism, and taking into account the various avant-garde movements born at the end of the century and before

World War I, and where the term Déco will have reference specifically to the "decorative arts". The terms used in the United States were more ambiguous (some say more confused), being associated with a different and new cultural situation. Following the lead of such American experts as Barbara Capitman, Patricia Bayer, Alastair Duncan and the recently deceased David Gebhard, we shall therefore use "Deco" as an umbrella term for the most diverse manifestations of the "modern" in America, connected to the birth of the field of industrial design, the laws of the marketplace, and to the desire to explore the new possibilities opened up by the so-called Machine Age. In our view, American Deco has acquired its own instantly recognizable and undeniable identity.

Another of the problems to which we will return in the course of our work concerns the limited theoretical awareness of American architects and designers in comparison to European artists who were more rigorous and better informed, often politically and socially engaged, at least up until the late thirties when, as is well known, the historical context changed. Even if this evaluation is valid, and leads some scholars to negate the existence of an American "modern" movement in the figurative arts in general, and in architecture in particular, it is nonetheless true that in the United States the encounter between the artist and mass production, as a result of the availability of new materials, creates in the artist a precise consciousness regarding the production process in which the two poles of maximum functionality and maximum decorativism — kept separate in the European context — are merged into a single condition of

reflection. American Deco, then, rather than being a well-defined and unambiguous style, became a condition of production of style. In a primitive way — one might say, in a "pre-postmodern" way — Deco in the United States came to incorporate diverse styles under the aegis of a common taste. It is to the quest of this taste, perhaps the last "taste" as such, that we will dedicate our journey through the American cityscape, both real and cinematographic.

America is, in fact, a place where everything seems to acquire a cinematographic dimension, where life appears once more to imitate art. "It is the same with American reality. It was there before the screen was invented, but everything about the way it is today suggests it was invented with the screen in mind, that it is the refraction of a giant screen. This is not like a Platonic shadow play, but more as if everything were carried along by, and haloed in, the gleam of the screen" (Baudrillard, 55).

More than a study of architectural styles, this book seeks to provide a panoramic view of a whole world of cultural, social, and aesthetic tendencies. It focuses on the period of the nineteen twenties and thirties as an example of hybridization, influence, and original reinvention, in fashion and in style. Rossana Bossaglia, writing about the fleeting quality of the Deco phenomenon, speaks of "taste" rather than of style, a taste connected to the historical reality which gave it expression: "that widespread taste of the twenties which tends to assimilate to itself every formal manifestation, and bring it to an average, that is to say, to a common level" (Bossaglia, *L'Art déco*, 5).

The numerous buildings which can be called "Deco" have panels and pediments decorated with stylized flower motifs in gently modulated, "streamlined" curves. They have geometric elements now known as "Jazz Moderne" or "Zigzag Moderne." They have splendid metal ornaments; sculptures and bas-reliefs which may at first appear classic or primitive but are unequivocally modern: elements of terra cotta, glass, metal, or plastic, colored and juxtaposed to produce the typical chiaroscuro effect. The newspapers of the era spoke, with regard to the style, of "universalism."

This set of tendencies in architecture and in design, despite their variety and multiplicity of aspect, actually have something in common, a certain trait which makes them recognizable, and which makes the viewer say:

"This is Deco." In the course of defending the preservation of that "sumptuous and horrendous" monument, the Fair Park Esplanade in Dallas, designed by George L. Dahl, and built in 1936 to celebrate the Texas Centennial, Marina Isola wrote in the *New York Times*:

Art Deco emerged in the 20's and revolutionized American popular design, introducing new shapes and such novel materials as chrome, vinyl, Bakelite and tubular neon. It was also the last comprehensive design movement, putting its stamp on everything from cutlery to building façades: along the Grand Concourse in the Bronx, green metallic tiles and zigzag patterns can still be seen, and in Miami Beach, pastel Deco hotels have been renovated to an exaggerated glamour. In Manhattan, entire blocks are occupied by such Art Deco monuments as Rockefeller Center, and the Chrysler, and Empire State buildings.[1]

Ours, then, is a discourse about an epoch, about a particular atmosphere which is found in every part of the country: from New York, with its powerful skyscrapers which exalt the myth of strength and greatness, to Hollywood with its enthusiastic crowds adoring Douglas Fairbanks and Mary Pickford, and making Rudolph Valentino the epitome of seduction and beauty, not only during his life, but even more after his death. It is not perhaps by chance that, in a cinematic transfiguration of reality, the Empire State Building becomes the backdrop, both fantastic and real, of the 1933 film *King Kong*. This American retelling of Beauty and the Beast transposes the fairy tale from seventeenth-century French villages and castles to the very heart of Manhattan. Metaphor for an impossible struggle between power and "otherness," according to some, or, according to others, one more dream of love between the beautiful and the wild, in which the wild is seen as fundamentally good, as a positive force in the making of America.

As we travel across the United States, from the Atlantic to the Pacific, we will encounter the manifestations of an art through which the young America of the twenties sought to express its pride in being the most powerful nation on earth, the nation which, through its intervention in the First World War, had resolved the uncertain fate of old Europe. Following the crisis of 1929, America did not lie down, but continued its dream of greatness as a way of redemption and consolation. The statue at Rockefeller Center of Prometheus snatching fire from the gods is a

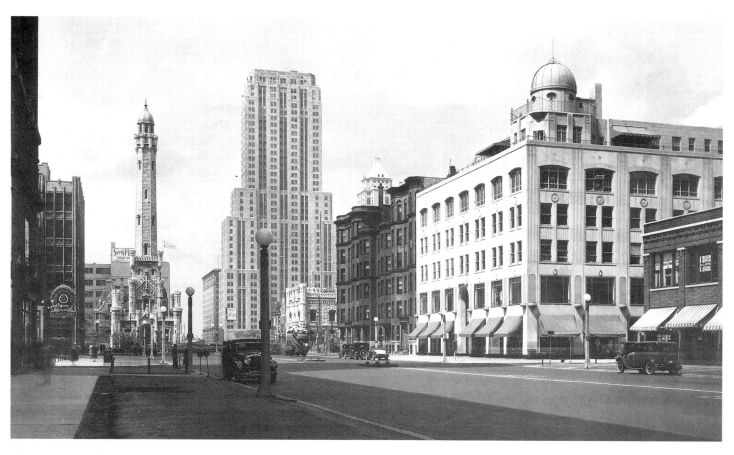

Chicago, View of North Michigan Ave., with Palmolive Bldg. (later Playboy Bldg., and now 919 North Michigan Avenue), (J. A. Holabird and J. Wellborn Root, Jr., 1927-29)*.

symbol of the daring, conquering American, and the buildings that rise into the sky like so many towers of Babel represent that gesture of courage and defiance, and of rebirth, which can be found in all American cities.

We have chosen Chicago, origin and cradle of the newest concepts of taste and style, as our point of departure, but New York is the true and most significant center of attraction in the country, beginning from that monumental symbol which is the Chrysler building, typical creation of flamboyant Deco. Together with Rockefeller Center, the Chanin building, the Empire State building, the Film Center, Radio City Music Hall, and the famous Waldorf-Astoria Hotel, New York acquired in the years between the two wars the characteristic profile we see today, and became the prototype of American civilization.

New York, then, was the city of power, as well as the city of efficiency and elegance, the emblem of an America that had conquered Europe, that would know how to react with stubbornness and pride even in the darkest years of the great depression. Looking back in "My Lost City" (1932), F. Scott Fitzgerald recalled New York in the carefree days of leisure:

The tempo of the city had changed sharply. The uncertainties of 1920 were drowned in a steady golden roar and many of our friends had grown wealthy. But the restlessness of New York in 1927 approached hysteria. The parties were bigger...the pace was faster — the catering to dissipation set an example to Paris; the shows were broader, the buildings were higher, the morals were looser and the liquor was cheaper... (Fitzgerald, *The Crack-up*, 30).

9

Before the 1929 crash, the immoderate worship of wealth was widespread and the possession of money became an overpowering aspiration. Alongside the traditional upper class of long-standing and solid fortunes had emerged a new class of nouveaux riches, who became the object of both emulation and envy among the lower middle classes. All the facets of this world are on display in F. Scott Fitzgerald's *The Great Gatsby*. We need only to look at the comparison that the author draws between the parties in the Long Island mansion of the fabulously wealthy Tom Buchanan and those of the newly rich Gatsby, where excessive luxury skirts vulgarity. To a society dominated by the allure of wealth and high living — no matter what the cost — Fitzgerald was at the same time interpreter and protagonist, and he was able to shed a disturbing light on the wide range of snobbish posturing and vapid, sometimes dramatic ambitions which defined the Jazz Age rich. [2] The same society of the "veddy veddy rich" is mirrored on the screen in Nick Grinde's movie *This Modern Age* (1931) starring Joan Crawford.

After the euphoria of the Roaring Twenties, the collective philosophy of carpe diem seemed to triumph. The intoxication with self-affirmation was followed by the more sober and self-reflexive period of the depression years. However, taking heart from newly elected President Roosevelt's affirmation that "The only thing we have to fear is fear itself," America did not give up its effort to make, to produce, to build.

On the opposite side of the country, Los Angeles, or more precisely Hollywood, presented a different, but complementary, visage from that of New York. It was almost as if, in the artificial life of cinema, somewhere between intoxication and distraction, one could get lost in the bliss of the present moment or the prospect of things to come. Hollywood was the Babylon of modern times, the city of vice and of the pleasure of transgression, privileged locus of madness and sin where the exuberance of real life confronted cinematic fiction and blended into it. In that world, Rudolph Valentino embodied the eternal myth of youth and charm, of that certain something, that "it" indefinable and imperious, which has been so well described by romance writer Elynor Glyn. In the mysterious and terrible encounter of life and death, Rudy, the Great Lover, was like the phoenix: he died, leaving behind a swarm of inconsolable women in mourning, and at the same time he delivered

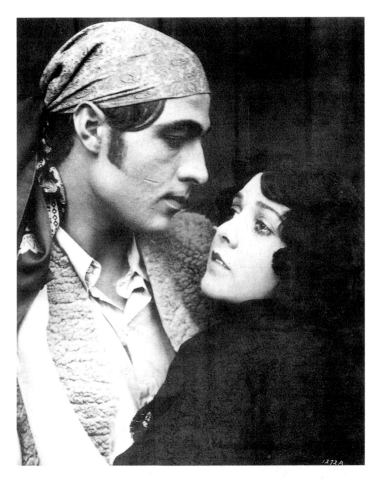

Rudolph Valentino and Lila Lee, in *Blood and Sand,* dir. Fred Niblo, 1922*.

himself over to immortality and myth. Not even death could graze those divine creatures of Hollywood, eternally young and beautiful. The tombstone of the fascinating Barbara La Marr, who died at just thirty in 1926, bears the inscription "With God in the Joy and Beauty of Youth." [3] But, although recklessness and scandal seemed to have no limits in the real life of Hollywood-Babylon, the implacable scissors of censorship never failed to impose the canons of a puritanical morality on the movies of that same era, which always finished with the inevitable and reassuring "happy ending."

The civilization of communication and mass entertainment was born: in addition to the movies, radio

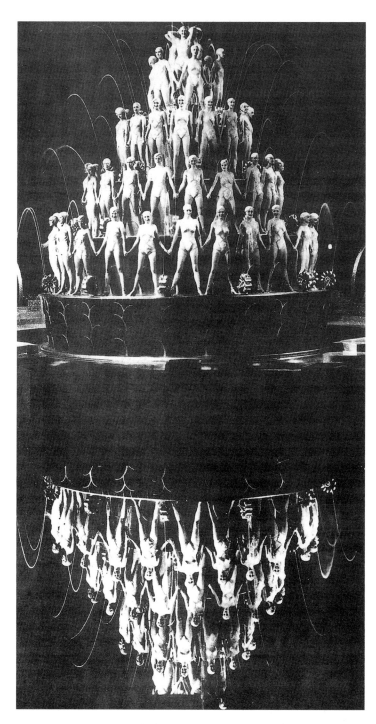

"By a Waterfall", *Footlight Parade,* dir. Lloyd Bacon, 1933, chor. Busby Berkeley*.

enjoyed widespread and immediate success, a fact recalled with ironic nostalgia in Woody Allen's *Radio Days* (1987). From New York, with its Radio City Music Hall, to Los Angeles, to the Hollywood of the "Golden Age," everything was unified and amplified by the air waves. The grandeur of New York's skyscrapers came to fill the screens of Hollywood's phantasmagoric movie palaces. Although the other cities included in our itinerary owe much to these two models, we shall, in visiting them, be looking for their small, local differences, for additions and variations, in a series of detours, digressions, and stops according to a personal choice of inclusions and exclusions, following the counsel of Pascal: "A digression on each point in order to reach the center."

We are looking then, as already noted, for that atmosphere in which America, while going through its most enthusiastic phase of self-fashioning, revealed itself in all its protean diversity, while nonetheless arriving at a surprising unity. This will not be a mere tour of some exemplary sites. The itinerary we propose is first and foremost a foray into the confines of an epoch, through diverse and varied levels in the history of culture and taste, from cinema to fiction, from architecture to musicals, with some excursions into the world of fashion and jazz; from the inside to the outside, in sum, of the "great American dream."

The architectural infrastructure of the United States which took shape in the years following the Civil War will always seem to have been generated by a kind of collective dream, one of those dreams in which everything is mixed up and then reconstructed from diverse fragments, from, in John Ruskin's phrase, the "stones of History."

At that time, the reigning idea was the recovery of an origin, remote in time and space, situated in a manneristic Orient of the imagination, which would serve as the starting point for a search ending in the affirmation of one's own identity and diversity. This process, developed by Henry H. Richardson and other architects after him at the end of the nineteenth century, was based on a concept of progress and evolution in history, particularly in that way of understanding history which, in the field of architecture and of taste, is represented by eclecticism. Such an approach leads to both the confirmation of history, and to its negation, since it levels and mixes all periods and all styles.[4]

If we look at the America of the Byzantine and

Romanesque revival, before the revolutionary experiments of Frank Lloyd Wright, we discover a country in search of its origins, a search expressed also in its architecture, which, albeit created with new means to serve new ends, still participated in a historical development. This is evident for example in the revival of neo-classic and neo-gothic forms, precisely because the revival of those styles meant the refusal to cut the umbilical cord with a homeland by then only imaginary or imagined, whether Byzantine, Mediterranean, or northern European.

Beginning in the twenties, however, and with the rise of Art Deco, America communicated to the world and projected on movie screens the moment of her birth as a "new" country which no longer needed to look at the past or to worry about the future. Looking back, there was no longer any history, there was only the present as a fixation on perennial youth. It is quite significant that the ornamental leitmotif was precisely the fountain of eternal youth, as seen in the choreography of so many musicals, or in the foyer mural of the Radio City Music Hall. It almost seems that America, above all in the Roaring Twenties, was frozen in time, restless and unbridled — and a bit hysterical, as Fitzgerald said — in her movement "in place," as if tap dancing or doing the Charleston. Herein too is a possible explanation for that frenetic drive, incomprehensible to conservative "old" Europe, to demolish and rebuild, to engage in continuous metamorphosis.

This was the indomitable youth of America: self-satisfied, almost suspended outside of history, in a posture which constitutes the very essence of the modern as a rejection of anything which is not "new." The America of those years did not look for historical sources or archeological traces foreign to its own territory and culture. We should not be fooled by examples and motifs taken from exotic ancient civilizations. These have only a decorative function, elements of pure line and ornament used to express the highest degree of sophistication. Like a wealthy society lady, America decorated its public buildings and its private mansions with jewels and accessories bought in Paris and at the European art markets, fancifully reinterpreting them with a highly personal touch all her own. Echoing Griffith, we can say that this period marked the "Birth of a Nation," and, like the title of a famous book by Van Wyck Brooks published

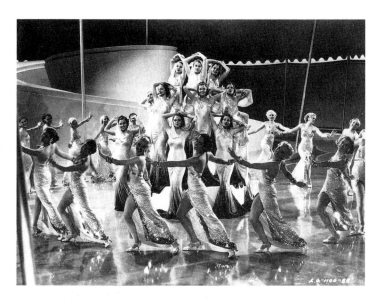

Strike me Pink, dir. Norman Taurog, 1936*.

in 1915, that it was "America's Coming of Age." After all, it is America, as Gertrude Stein remarked, which invented the lifestyle of the twentieth century.[5]

The twenties and the thirties were also the years of prohibition and, let us not forget, of the great economic crisis. At that time, there was in many people the desire to escape, a wish for intoxication and oblivion which could be found in the old continent, where one could live a season of fanciful immoderation without restraint and without restrictions: "The summer of the thousand parties," as F. Scott Fitzgerald said in 1925. Thus began the epoch of the pampered expatriates, intellectuals who, in their migratory journeys back and forth across the Atlantic, enjoyed the idle life of the great ocean liners, veritable floating cities, whose décor, like that of the legendary French liner *Normandie*, was rigorously Deco. Fitzgerald himself went abroad, as did Henry Miller, Ernest Hemingway, Gertrude Stein, Djuna Barnes, Sherwood Anderson, Man Ray.

It was also in 1925 that Josephine Baker, having left her native St. Louis, found fame and fortune in Paris as a singer, dancer, and movie actress. Even away from home, Americans seemed to want to stop time in order to create for themselves an artificial space in which they could

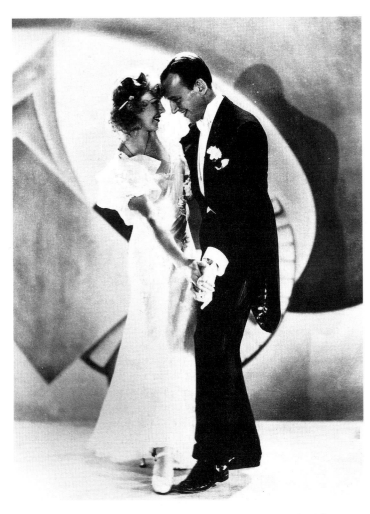
Fred Astaire and Ginger Rogers, in *Flying down to Rio,* dir. Thornton Freeland, 1933*.

Fitzgerald's novel *The Great Gatsby*, Fernanda Pivano gives us a rich and lively picture of the decade between the end of the First World War and the great Depression, that decade which, from the title of a collection of short stories by Fitzgerald published in 1922, was called the "Jazz Age." Indeed, jazz provided the background music of the epoch, thanks also to the coming of age of the record industry. In New Orleans, in Chicago, in Harlem, one could listen to bands and soloists already famous or destined to future glory. The cornet of Bix Beiderbecke, the trumpet of a very young Louis Armstrong, the orchestra of Paul Whiteman, which made a name for itself in 1924 with Gershwin's "Rhapsody in Blue," enchanted all jazz lovers. The Cotton Club, the most famous night club on the East coast, became an instant legend. Opened in 1928, it had a large, horseshoe-shaped hall decorated with artificial palm trees, which was designed by Joseph Urban. Ladies in ermine coats and gentlemen in formal attire gathered there to admire the virtuosity of Cab Calloway, Ethel Waters, and especially Duke Ellington, undisputed king of the keyboard.[6]

This period witnessed the establishment of feminism, the spread of the automobile, the high tide of capitalism, and the rise of the "great red menace." It was "the decade of all the protests and of all the revolts, of the most optimistic utopias and of the cruelest disappointments....It was a time when all gestures, even those that now in historical perspective seem insignificant, took on an aspect of protest, of defiance" (Pivano, 22). But, in spite of some shadows, the prevailing mood was one of optimism in the certainty that the great universal utopia of well-being, "a chicken in every pot," would become a reality for all, from the industrialist to the laborer. The prevailing view was that the prophecies of Whitman and Emerson for a prosperous and happy America were on the verge of coming true.

The year 1920 was an annus mirabilis. After the sacrifices of the war years, quoting Pivano again, "people did not want to hear any more talk of war, they wanted to hear of peace and to have fun in all possible ways....Anything goes when one wants to have a good time; and America offered its people plenty of opportunities." It offered radio, movies, Fords, and with them a frenzy for speed; and finally, it offered sports, from the most popular, like baseball, to the more elitist, such as tennis and golf. These were the innocent pastimes, but there was no shortage of

move to the rhythms of jazz and the Charleston, or to the melodies of George Gershwin, who made a name for himself in 1920 with "Swanee," popularized by Al Jolson, and made his defining contribution to the epoch in 1928 with *An American in Paris.* As Cagidemetrio puts it, in the "network of expatriates, the American in Paris experiences European culture, searches for new forms for a country and a new identity in new times...but, above all, the expatriate in Paris discovers what it means to be an American." (Cagidemetrio, 12).

In the introduction to the Italian translation of F. Scott

lovers of vice. Whereas the belle époque had celebrated its gaudiness and its illusions with rivers of champagne, now the fashion, even for women, was hard liquor, and not even prohibition could curb its use. Cocktails were the great vogue of the moment; they had been invented to liven up the dinner parties where people went on drinking until dawn. `

The two phenomena which marked this era were prohibition and gangsterism. And with them came the rise of the likes of Al Capone in the Chicago of machine guns and armored cars. The movies told stories of gangsters, and still do, as in Woody Allen's *Bullets over Broadway* (1994) which recalls those years with felicitous allusions, like the interiors in Deco style and the boss's blonde moll. When prohibition was repealed in 1933, the gangsters simply switched businesses, moving from bootlegging to gambling, racketeering, and prostitution. Corruption was rampant in police departments and government agencies. The mob made the headlines practically every day. This kind of journalistic material turned out to appeal to the general public much more than the conquest of the West or the gold rush. Hollywood seized the opportunity to revitalize the already popular gangster movie, and in the process managed to historicize the mob's exploits as they were happening in Chicago or New York.

The situations and protagonists of organized crime were reconstructed with a basis in reality, and at the same time, reinvented using new formulae: an unscrupulous view of business, a heightened individualism, and also a greater sensibility in the domain of human feelings. Beginning with *Little Caesar* (1930), the archetypal gangster film, by Mervin Le Roy, starring Edward G. Robinson in the title role; with *The Public Enemy* (1931) by William Wellman with the unforgettable James Cagney; with *Scarface* (1932) by Howard Hawks, with Paul Muni, George Raft, and Boris Karloff — all great successes of Warner Brothers — Americans could look at their troubled present, with the help of the illusion that in the end everything would turn out all right, and the "bad guys" would be punished. The end of prohibition also coincided with Franklin Roosevelt's inauguration and the beginning of the New Deal. Americans had reason to hope that better days were ahead.

As everyone knows, prohibition led to a black market which represented both a challenge to the law and a revolt against everything and everybody in the name of absolute freedom: the freedom to get drunk in those forbidden places known as speakeasies. It was considered quite the sophisticated thing for men, and even more so for women, to whisper the password while, with a shiver of fear mixed with pleasure — the shiver of the forbidden — they looked out for the police. To drown yourself in alcohol, to dance till you drop at wild parties, were considered almost a fashionable obligation for the young of the jazz generation who rushed happily and madly towards their own destruction: beautiful and damned.

And "the beautiful and the damned," as described in Fitzgerald's novel of the same name, seem to be closely related to the "devilish" women who appear in the concluding pages of Djuna Barnes's *Nightwood*:

Then she began to bark also, crawling after him — barking in a fit of laughter, obscene and touching. Crouching, the dog began to run with her, head-on with her head, as if to circumvent her; soft and slow his feet went padding. He ran this way and that, low down in his throat crying, and she grinning and crying with him; crying in shorter and shorter spaces, moving head to head, until she gave up, lying out, her hands beside her, her face turned and weeping; and the dog too gave up then, and lay down, his eyes bloodshot, his head flat along her knees (Barnes, 139).

Barnes' characters, "lesbians, idiots, homosexuals, swindlers, drug users," writes Elémire Zolla, "are larger than life...but the discovery is the same as Fitzgerald's: what fascinates us in the society's products, be it the flapper's casualness and vitality or the extravagance of the rich and fanciful Gatsby, is in fact schizophrenia and obsession" (Zolla, introduction to *L'età del Jazz,* 11). Perhaps even more than Gertrude Stein, Djuna Barnes represented, among the expatriates of the lost generation, the rebellious and singular woman who asserts herself through transgression.

These were triumphal years for women: in 1920 they were granted the right to vote and feminism made new converts. Even industry addressed women's needs with the introduction of mass-produced household appliances — a fertile field for creativity in design — which liberated women from the heaviest burdens of housework. As a result, women's autonomy presented itself in the two parallel facets of the woman who by day easily took care of her house, or got ahead in the business world, and then by night became the dashing queen of dances and parties.

This was a new and uninhibited woman who, scandal of scandals, had the impudence to cut her hair and shorten her skirt. In high society, the flappers were a great hit, and Fitzgerald called one of his early books, published in 1920, *Flappers and Philosophers*. These frivolous beauties cut their hair like men; and their bodies, free from corsets, revealed their shapes under short and loose pastel dresses made of satin or voile in the styles of Poiret and Chanel.[7] The most stylish women smoked cigarettes with long, ivory cigarettes holders, used Coty makeup and Guerlain perfume; their jewelry was by Boucheron, Van Cleef and Harper, Cartier; and, much to the shock of the self-righteous, they wore shiny flesh-colored rayon stockings. Featured in some of the most famous magazines, such as *La Gazette du Bon Ton* and *Femina* in Europe, or *Vogue*, *Vanity Fair*, and *Harper's Bazaar* in the United States, fashion became an important medium for the diffusion of the new taste and the new style. For many years, *Harper's Bazaar*, which belonged to the chain of the famous newspaper magnate William Randolph Hearst, employed the talents of the great designer Erté. Graphic art and advertising in the new style quickly became popular everywhere: printing and book production, magazine covers, publicity notices, theater and movie posters, all followed, and in their turn created, immediately recognizable, indeed unmistakable new styles in the modern or modernistic look which came to be called Deco.

Typography and poster design too developed according to the new demands and tastes, both in Europe and in the United States. A stylized line and semi-abstract type became the trademark of Cassandre, the greatest French poster designer, whose contribution to the evolution of Deco was Bifur type, issued in 1929 and, as Cassandre himself said, "designed for advertising…designed for a word, a single word, a poster word."[8] In America, typefaces such as Broadway, Parisian, and Irvin — the latter was used for the cover title of *The New Yorker* — had great success, uniting elegance with an eye-catching look which made them very useful for commercial purposes.

It all began, as is well-known, with the great *Exposition Internationale des Arts Décoratifs et Industriels Modernes* held in Paris in 1925. Nevertheless, it would take several decades to arrive at a precise definition of the new style and to settle on the use of the term "Deco." In the early twenties, there were in fact a number of diverse trends in style and taste, developing according to different exigencies in the various countries in which the Deco style took shape between the twenties and the early forties. At the beginning of her fine book *Art Deco Architecture*, Bayer writes: "Art Deco architecture is a particularly hard concept to define. It refers to a decorative style at once traditional and innovative, which absorbed influences from a variety of sources and movements, and introduced a whole range of new or improved materials into the vocabulary of architecture" (Bayer, 7).

Two scholars in particular have contributed to the analysis of the origin and terminology of the Deco movement, and we shall refer to them for what concerns the fundamental nature of the problem. They are Bevis Hillier, writing in English, and, for the Italian perspective, Rossana Bossaglia.

Hillier's 1968 book is credited with establishing the use of the term "Art Deco" in English, adapting it from the important anniversary exhibition held in Paris in 1966, which was entitled *Les Années 25*, and whose catalog had the subtitle "Art Déco." In fact, notwithstanding the variety of terms which had been used to refer to the period in question — Moderne, Modernistic, functional style, Jazz Moderne, Zigzag Moderne, Aztec Airways, International Style in the thirties, and Cinema or Hollywood Style in the forties — references to the seminal Paris Exposition continued to recur, as in Paris 25, Style 1925, La Mode 1925, establishing this event as a kind of common denominator. It was in fact the basis of Hillier's choice because, as he writes in *Art Deco of the 20s and 30s*, "It was at this exhibition that the new style was first presented to the world as something obviously new" (Hillier, 11).

In Italy, as noted, Rossana Bossaglia, whose work was preceded by Giulia Veronesi's important studies, must be credited not only with the most important and far reaching essays on Art Deco in Italy and abroad, but also with precise and pointed remarks on the use of the term and its history, beginning with her 1975 book on Italian Deco. The progressive transformation of the term from Art Déco to simply Deco also corresponds, according to Bossaglia, to a modification of the concept itself. "The expression 'arts décoratifs' was applied generically to a wide range of artistic applications to industrial objects.

'Arts déco' was more specific, referring to the production of those refined objects which had characterized the twenties, particularly in France, to the ideology that had inspired them, and to the presentation of those objects at the Paris Exhibition in 1925. This latter expression, therefore, denoted a particular period and a particular taste" (Bossaglia, *L'Art déco*, 145).

This taste was, especially in the beginning, a matter of fashion, and was limited to an elite circle, but later it spread, gaining the favor of the middle class, and even of the lower classes, and coming to characterize everything from advertising posters to scented calendars hanging on the walls of beauty parlors and to the most common objects of domestic consumption. Still later, Bossaglia continues, "The term 'Déco'...tended, whether consciously or not, to sever its connection with the decorative arts...and to shift its reference to a much wider range of artistic expression. Moreover, for a number of years already, people had been speaking and writing of 'art déco' in the context of architecture."

Thus, in Europe, Art Déco was born first and foremost as a form of decoration of objects, characterized by an awareness of the problems of form and style in relation to the mass production of industrial articles. Only later would its domain be enlarged, extending from objects of general consumption to architecture.

But if Déco was initially a matter of taste rather than of style, it would in fact become a style. As a taste/style, Déco design had a complex relation to the architectural styles of the time, styles which lent themselves more easily to theorizing, and in which the triumph of the machine and of technology represented the "world of the modern."

By the end of the nineteenth century, people were already talking about the "tradition of the new," and the varied movements that follow upon or run parallel to one another in Europe at the beginning of the twentieth century — all holding themselves out as standard bearers for the avant-garde — were manifestations of what has been called the modern movement. From Art Nouveau, whose name announces its intention to be new, to the linear asceticism of architects such as Gropius and Le Corbusier (whose building for the 1925 Paris Exhibition was called *L'Esprit Nouveau*), from the youthful exuberance of the Viennese Secession to the floral extravagances in wrought iron by Edgar Brandt, to those

evolutions of Art Nouveau which can be found in Mackintosh or Horta, from the geometry of the cubist movement to Italian futurism — Art Déco took its inspiration from all these currents, sharing the stage with some, succeeding others.

We turn again to Hillier for a working definition of the style in question, in terms of a synthesis of characteristics and influences:

An assertively modern style, developing in the 1920s and reaching its high point in the thirties; it drew inspiration from various sources, including the more austere side of Art Nouveau, cubism, the Russian Ballet, American Indian art and the Bauhaus; it was a classical style in that, like neo-classicism, but unlike Rococo or Art Nouveau, it ran to symmetry rather than asymmetry, and to the rectilinear rather than the curvilinear; it responded to the demands of the machine and of new materials such as plastics, ferro-concrete, and vita-glass; and its ultimate aim was to end the old conflict between art and industry, the old snobbish distinction between artist and artisan, partly by making artists adept at crafts, but still more by adapting design to the requirements of mass-production (Hillier, 13).

What has been said so far works for Europe, but what about the United States?

The United States did not participate officially in the great Paris Exposition because, according to the Secretary of Commerce at the time, Herbert Hoover (of all people!), American designers could not meet the entry requirements, which called for works showing "new inspiration and real originality....Reproductions, imitations, and counterfeits of ancient styles will be strictly prohibited." [9] But even if America as a nation was not officially represented at the Exposition, there were many American visitors and observers in Paris, particularly those artists or self-exiled intellectuals of the so-called "Lost Generation," who would act as intermediaries between two tastes and two worlds.

The origin of Art Deco is European, but those Americans who flocked to Europe in the Roaring Twenties, particularly to live in Paris, had the opportunity to be exposed to the new ideas and to accumulate precious art objects. They brought back home glassware, silver, jewelry; they had occasion to receive and to offer new suggestions. This was the birth of modern design, which incorporated the most diverse materials, from wood and

steel to plastic and glass, into the furniture, draperies, and veneers used to decorate the interiors of everything from "Grand Hotels" to department stores, movie houses, and lobbies of commercial and public buildings, not to mention elevators and transatlantic passenger ships. The exteriors too were adorned with characteristic and unmistakable Deco ornamentation.

Thus European Déco became American Deco. And in the process, America erased its debts, creating an art form all its own, in which art was joined to industry. American Deco is truly a "total," all-encompassing style. Through the democratic diffusion of its canons and stylistic elements, it would place its imprint not only on skyscrapers and public buildings, hotels and apartments, theaters, movie houses, auditoriums, bridges and churches, but also airports, shops, hospitals, service stations, and factories. Thus was born an industrial art which stood ready to dignify any building, from the repair garage to the tire factory, not to mention the famous diners, which would remain popular through the nineteen fifties and beyond.[10]

As far as the production of decorative or industrial objects is concerned, the birth of a modern American style goes through several stages. For better or worse, what was most fashionable around 1925 was European. The architecture critic Richardson Wright, returning from the Paris Exposition, emphasized the problem facing American design. Specifically, due to its high level of economic prosperity, the United States was developing advanced technology in various fields, and was conquering world markets with new products such as automobiles, household appliances, and other mass-produced products, and yet it was not creating a style which fit those products: "We live in an age of motor-cars, radio and air transportation, and yet we are satisfied to have houses that were created to suit ages when none of these improvements were dreamed of. We listen to radio in a Louis XVI living room, drive our motors up to early Italian villas, and land our airplanes in gardens that might have been laid out by Le Nôtre. Why not chuck the whole bundle of ancient sticks and create styles of our own, styles suitable to the age in which we live?" (Duncan, *American Art Deco*, 13)

At this point we should note a curious paradox, one which underlies the difficult birth of "American Modern," and which concerns what Richardson Wright regarded as the conservative conformism of an otherwise eclectic era.

This is the fact that a nation as young as the United States could not feel, like old Europe, the burden of history, and consequently could not feel the desire to break loose from a past it does not have. But there is another paradox behind the uncertain success of the new forms: a kind of modernist hysteria which, until a few decades ago, would lead architects and city planners to destroy old structures and replace them with new ones, without regard to all the history — even if of a relatively short period — which was signified by those layers of culture and civilization.

Several exhibitions mark the stages of this transition and eventual emancipation. In 1926 Charles Richards (who in his capacity as Director of the American Association of Museums led the American delegation to the Paris Expo) organized a traveling exhibition of objects on loan from Paris. In the span of a few years many other shows followed, and many American designers began to participate in them. In an interesting conjunction of art and marketing, the places where these exhibitions were organized included museums and art galleries, but also department stores like Lord & Taylor and Macy's, thus making clear once more the close connection between art and industry, and indeed, celebrating their cooperation.

The most important of these shows were held in New York, in 1928 and 1929. The first, *An International Exposition of Art and Industry*, took place at Macy's, where European and American architects set up fifteen completely furnished model rooms. As Victor Arwas puts it, "The theme that this was modern design was so drummed that it became known in the United States as Art Moderne or, more simply, the Moderne. Yet even as it was being copied, it was being transformed to a uniquely American variation of the style" (Arwas, 22). In the catalog published for the occasion, the enthusiasm for the new stands out: "The modern man of culture, with his up-to-date attire, with his motor-cars, railways, airplanes, is a living proof of the fact that the power of creative art has not gone from our time."[11]

The second and even more important show, *The Architect and the Industrial Arts: An Exhibition of Contemporary American Design*, was held at the Metropolitan Museum one year later, in 1929, and this time the emphasis was on the fact that American art was being shown. Under the direction of Eliel Saarinen, eight architects (Raymond M. Hood, Ely Jacques Kahn, Joseph Urban, Eugene Schoen, John Wellborn Root, Armistead Fitzhugh, Leon V. Solon,

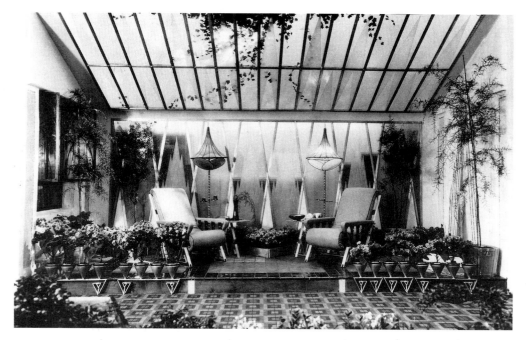

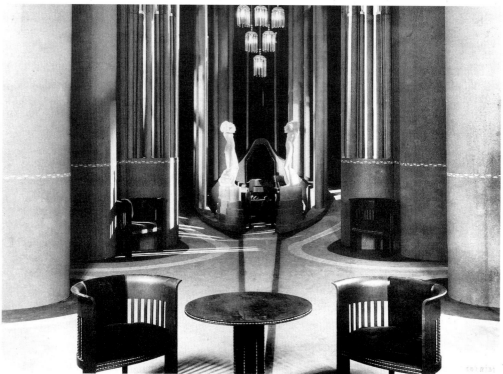

Joseph Urban, "Sun Room", Metropolitan Museum Exhibition, New York, 1929*. - Joseph Urban, Set from *Young Diana*, 1922, starring Marion Davies*.

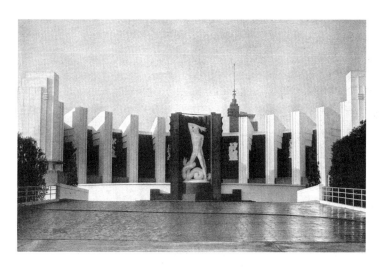

Chicago, The North Court of the Hall of Science, (now demolished), from the *Official Pictures of a Century of Progress Exposition, 1933**.

Ralph T. Walker) participated, and each one of them designed a room, complete with furnishings and accessories. This show defined the bases of a distinctly American approach to design: economy of means and resources, a cleaner line, and a predilection for new materials, such as metal and plastic. The resulting functionality and freedom of expression led the Italian architect Gio Ponti to observe wryly that these developments were taking place only "away from home."[12]

Two examples illustrate this conscious change in American design: the abandonment of the "decorative arts" for the "industrial arts" of the machine age. The designer Paul Theodore Frankl produced an unmistakable line of furniture called "skyscraper," using California redwood studded with turquoise, but inspired by Japanese furniture. And Donald Deskey implemented the principle of utilizing modern materials for modern interiors in the decoration of Radio City Music Hall (1931), as well as in his "room for a man" of 1928, "a beautiful room with…a metal table with vitrolite top, and curious, exceedingly interesting cork walls in shades of brown. The ceiling of aluminum and the little alcove recessed in brilliant tones."[13]

Whereas the twenties had been characterized by a luxurious, elitist, and therefore uncommon Deco, represented by objects imported from Europe, the thirties witnessed the wider availability of articles for interior decoration in department stores, thus offering a much less costly alternative to expensive French products. The American dream of greatness mentioned earlier transformed itself, not in type but in intensity, and seemed to result in true democracy. The portal of Bullock's department store in Los Angeles bears the inscription "To build a business which will never know completion." The great monuments of American capitalist democracy were becoming the great Expositions and their successors, the shopping centers. The recent restoration of the Fair Park Esplanade in Dallas, mentioned earlier — a monumental complex of 26 buildings, fountains, statues, aquariums, mermaids, winged horses — is important because it is the only complex of this kind still intact in the Unites States, a place "where the Art Deco clock stopped in 1936."[14] But Fair Park is equally important because it recalls a time when such places gave rise to wonder on the part of a public still optimistic about the future. The optimism was nurtured by the policies of industrialists such as Henry Ford who, beside promising workers higher wages, created for industrial production the slogan: "The best possible product at the lowest possible price." The great aspirations of the fin-de-siècle Liberty style, which sought to reconcile the functional with the beautiful by beautifying the industrial object, seemed to have been realized without any of the inferiority complexes which, in old Europe, had characterized the problem of reconciling the idea of the uniqueness of a work of art with the possibility of its mass production.

So there was a great euphoria for modernism and design in America: the Museum of Modern Art in New York was founded precisely in 1929, and MOMA would become a constant reference point for modern art and design. While Deco flourished in Europe for only a decade, during the twenties, in the United States the style/taste/fashion of Deco continued to thrive all through the thirties, and even extended into the war period, thanks to the rise of the professional designer, who contributed to a new thrust in the economy and the market after the great Depression. The birth of sound cinema in 1929 and Roosevelt's New Deal contributed to rendering those difficult years less traumatic.

"Art Deco architecture was an architecture of ornament, geometry, energy, retrospection, optimism, colour,

texture, light and at times even symbolism," writes Patricia Bayer, and she goes on to use adjectives such as "vibrant" and "unexpected" in the attempt to define a style which was "at once an official, vernacular and fugitive architecture, encompassing, respectively, monumental, yet exuberantly ornamented, city halls, schools and post offices, gleaming roadside diners and streamlined dry cleaners, and fantastic world fair pavilions" (Bayer, *Art Deco Architecture*, 8).

Thus in the United States, too, Art Deco incorporated various styles, amply borrowing from the schools of modernism which preceded it. But above all, there were two European movements of the first quarter of the twentieth century — the decorative and the functional — which, with due modifications, would form the nucleus of the parallel American movement. They were the two souls of the 1925 style. From Austria and Germany, the tendency towards a more logical and geometric modernism, as practiced by the Bauhaus and *Jugendstil*, emphasized functional design applicable to mass production. From France, on the other hand, came the tendency towards decoration, with more opulent and elaborate ornamentation, and a penchant for luxury and leisure, pleasure and conviviality, which arrived in the United States even before the more severe style. Both tendencies can be found in America, and they were developed by American architects and designers and by expatriates from Europe before and during Nazism.

It was a time of great dynamism and cultural exchange between the two shores of the Atlantic, especially before the 1929 crash. There was a very broad cultural bond, with American intellectuals in Paris and immigrant European architects in the United States. Architects such as Saarinen, Urban, Schindler and Neutra not only imported Deco from the old continent, but they also in part transformed it and translated it into an American language, as happened also for the movies through the work of immigrant directors, such as Fritz Lang and Ernst Lubitsch.

In the thirties, when the political climate in Europe darkened, many European artists, especially German ones, left their homelands and came to the United States where, together with Frank Lloyd Wright and his heirs, they gave life to a unique phenomenon. This is not the place to discuss the fact that the relationship among the various schools was not always idyllic; what we wish to emphasize here are the results. In fact, in spite of all these European contributions with their sometimes difficult interrelationships, American architecture and the decorative elements that characterize it, turned out in the end to be mostly homegrown. Consider Richard Neutra who, recognizing the importance of Sullivan and of the Chicago School in the birth of modern architecture, joined forces with Wright, albeit with inevitable differences, and built houses in the Hollywood hills where beauty and functionality, "magic and technology," blend together.[15] A new type of designer-architect appeared who, like Wright and Neutra, wanted beautiful and functional homes. What in Europe, and particularly in Italy, was often only theory, became in the United States, in the civilization of the machine — although not without its own contradictions — practice and reality.

And within the Unites States there is mobility, from one coast to the other, from Chicago to New York to Hollywood, a mobility which facilitates exchange between art and life, design, lifestyle and cinema, and which would give to American Deco, despite its diverse forms, a distinctive individuality. A closer look shows a bit of everything in this incredible mixture: the futurist movement and cubism's rigid geometries, skyscraper profiles, and those one- or two-story houses inserted, or better still, rooted into the earth. All the styles were compressed and then reborn, not as before in a loose eclectic mix, but rather in an amalgam, a recognizable unity of traits and characteristics.

Thus, just as with the eclecticism of the beginning of the century, Deco in America, and particularly in architecture, forged a precise and autonomous physiognomy. As Bossaglia puts it, "the United States developed its own architectural style; and it is the only place where the style in question is eminently recognizable in the field of architecture" (Bossaglia, *L'Art déco*, 25). The main reason for this phenomenon is that the Deco style in America found its way into the urban setting, particularly in Chicago and Manhattan, with that absolutely unique and original contribution: the skyscraper. These immense structures made an impact on the imagination even of those European architects who regarded modern times as in many respects brutal and uncivilized. For example, in 1926 Erich Mendelsohn gave particular emphasis to the impact of economic power evidenced by the rapid construction of inhuman skyscrapers, witnesses to the

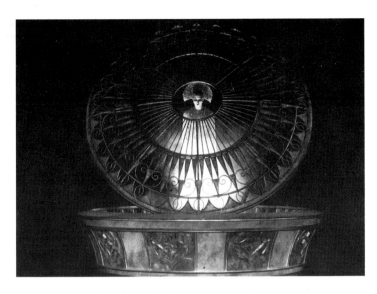

Metropolis, dir. Fritz Lang, 1926*.

power of money and fruit of the work of thousands of immigrants.[16] Criticism and enthusiasm are intertwined when Le Corbusier, seeing the Manhattan skyscrapers from the *Normandie*, exclaimed: "I saw rising in the mist a fantastic, almost mystic city. 'Here is the temple of the new world!'" [17]

Enthusiasm, wonder, and even fear commingle in the comments of the architects, in the troubling images of the first horror movies like *King Kong* (1933), or even earlier in *Metropolis* (1926), the movie that Lang made after a visit to the United States. It was while looking at the streets of New York that the director conceived his dystopic city of the future, with workers laboring underground in the darkness while above them, in clear daylight, a privileged class cavorted from parties to amorous encounters — a very different perspective from that of Fitzgerald's idle youth.

And we cannot help thinking of the fantasies of the comic strip artists, with their heroes temporarily dislocated in the future, like Buck Rogers or Brick Bradford (by Clarence Gray), and especially Flash Gordon (by Alex Raymond, 1934) during his first adventures in space. In fact, in the field of comic strips, the representation of futuristic and alien cities is influenced by Deco models which shape their appearance and suggest views both

troubling and fascinating. The presence of clearly recognizable architectural elements (often evoking the Orient) on the alien planets visited by Flash Gordon, acts as a counterpoint to the obsessive crowding and the clash of styles, creating in the reader a sense of disorientation.[18] The same effects can be found in the futuristic, and never realized, drawings of the "metropolis of tomorrow" by Hugh Ferriss,[19] an influential architectural renderer, drawings where reality and science fiction merge. In 1925, in an exhibition organized on the occasion of the third centenary of New York City, Ferriss displayed some of these drawings, and one critic saw in them a vision which surpassed that of Jules Verne.[20]

But if the sight of skyscrapers, like that of pyramids or mountains, give some people the spellbinding shiver of vertigo, they did not have the same effect on Frank Lloyd Wright. In a 1931 article entitled "The Tyranny of the Skyscraper" — whose impact was reduced by the fact that it appeared at a low point in his career — the famous architect wrote of these structures: "They are monotonous. They no longer startle or amuse. Verticality is already stale; vertigo has given way to nausea." [21] In the game of "what if," one could ask what would have happened to the American cityscape if Wright had had a more determining influence during that critical period.

At any rate, the skyscraper is a kind of modern, secular cathedral, whose majestic vertical thrust impresses "like the arrival at Lilliput of the immense stranger," as Ferriss (30-31) put it. But American Deco includes countless other buildings, stretching out horizontally as well as vertically, public and private buildings, monumental and modest ones, which can be seen in the most diverse areas of the country, and which mark stages in the evolution of modern architecture. And the debate over the birth of the modern in America has gone through several phases of development and of self-consciousness. Borrowing from the parallel discussion in literature, we can invoke Irving Howe's distinction between "contemporary" and "modern." Howe sees the contemporary as merely current, whereas modernity is a product of critical evaluation, implying considerations of sensibility and style.

Built into Howe's distinction is a sense of awkwardness about the culture of one's own time. Indeed, Deborah F. Pokinski notes that "During these years, the meanings of the words *modern, modernism, modernistic*, were in a

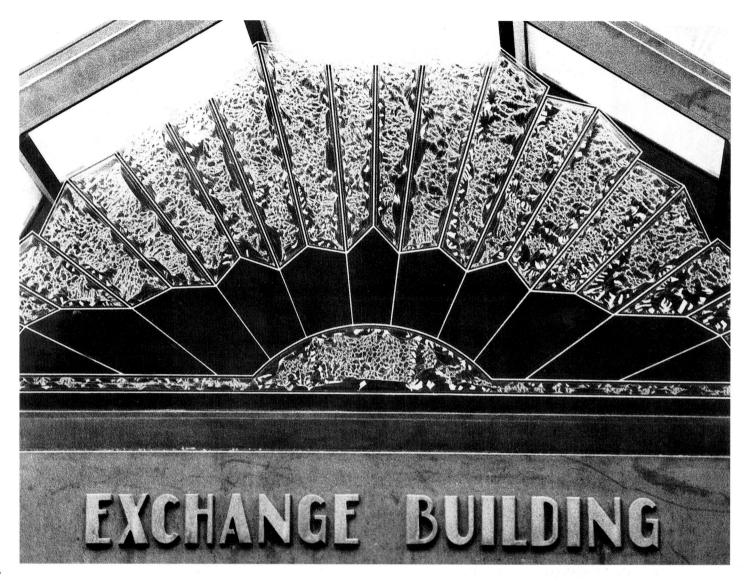

Seattle, Exchange Building, 821 2nd Ave. (John Graham, 1930), detail of the glass decorations.

From *Flash Gordon*, by Alex Raymond, 1937*.

more modernistic and would ultimately prove to be more influential — derived from a union of Viennese Secessionism, and the more progressive wing of Sullivan's school, whose motto "form follows function" had undoubtedly opened the way towards modernism (and it is not by chance that the young Wright trained with Sullivan).

There was much debate at the time over the question of the meaning of the term modernism, and these debates contributed to a heightened awareness among architects of the need to be up-to-date, the necessity to keep abreast of new trends, to adapt to the exigencies of the machine age, and to raise the standards of the profession. An article published in 1931 spelled it out: "We must cease to be copyists of the past, and must recognize that the society that these ancient forms adequately served has now passed away, that our duty is to develop equally effective and appropriate expressions of our own social order." [23]

And in 1933, Donald Deskey, the principal designer of the interiors of Radio City Music Hall, "the cavernous cathedral of Art Deco" (Capitman et al., *Rediscovering Art Deco*, 162) in New York, still saw American architects divided between the attraction for forms derived from other cultures and the painful awareness of the absence of a local, native tradition: "Our difficulty was in the fact of not being able to refer to a tradition, either by way of denial or acceptance." [24] All that has been said so far should help to dispel the view, maintained by Louis Mumford among others, that there was no "American" architecture before the thirties, that is, before the encounter with the International Style. In fact, although Mumford saw American architects as forced "to wander for forty years [from the World's Columbian Exposition of 1893] in the barren wilderness of classicism and eclecticism," [25] American architecture had already manifested its uniqueness and autonomy even before the famous French Exposition of 1925. Even the widely used exotic motifs, primarily Egyptian and Oriental, were not borrowings from the past, but were instead, as previously noted, simply decorative elements revisited according to the taste of the time. This was especially true of the geometries and grandiosities of Egyptian flavor, revitalized by the discovery of Tutankhamen's tomb in 1922.

An indigenous source of inspiration was the art and architecture of the pre-Columbian, Mesoamerican cultures, primarily Aztec and Mayan. Beginning in about

state of transition and were not always clearly distinguished in American architectural literature. In the American context, *modern* initially remained a more neutral term, while its derivatives, such as *modernism* or *modernistic*, were adopted to describe new architectural forms which at first appeared to be radically different, even bizarre, to many Americans" (Pokinski, 52).[22]

The debate between traditionalists and continuators of eclecticism on one side, and innovators and promulgators of an indigenous architecture on the other, had already begun when a competition was announced in Chicago in 1922 for the design of the new home for the *Chicago Tribune*. While the winners of the competition, Hood and Howells, continued on the road of eclecticism and gothic revival, the second place design of Saarinen — which was

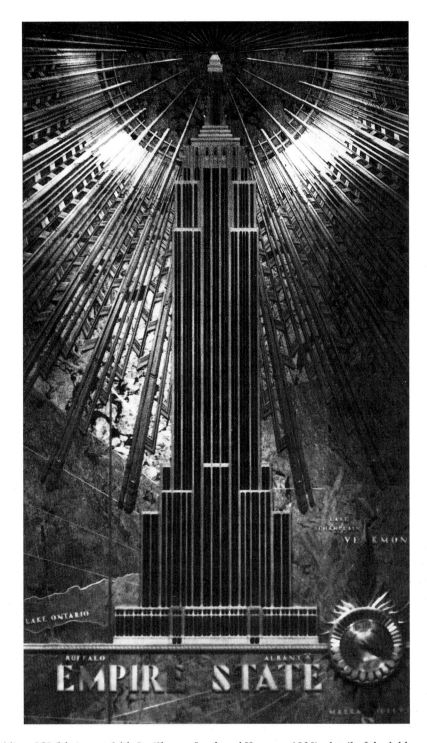

New York, Empire State Building, 350 5th Ave. at 34th St. (Shreve, Lamb and Harmon, 1930), detail of the lobby.

1910, both decorative motifs and architectural forms began to be drawn from these cultures, giving rise to what has been called the Mayan Revival style.[26]

The availability of these native American models contributed to the rejection of European "archeological" themes, with their air of nostalgia, in favor of the purely decorative, as reflected in line and ornament, in settings for movies and musicals, and in fashion, both in costumes for historical movies, and in contemporary furnishings. Papyrus leaves and lotus flowers, more or less stylized, made their appearance. Straight lines gave way to the zigzag. Skyscrapers took on more and more the form of superimposed receding terraces, often referred to as "ziggurat."

Frank Lloyd Wright can certainly be called the pioneer of all this, in the sense that, in the search for a specifically American art and culture, and for a renewed relationship with nature, he drew inspiration from the monumental Mesoamerican and pre-Columbian, that is to say, indigenous architecture. His mission was to find native roots. His highly personal style blended Mayan and Aztec motifs with the more cosmopolitan and international influence of the Viennese Secession. He laid claim to something wholly American, a proud affirmation of the self, of the kind found in Emerson and Whitman. There was no need to go in quest of a remote homeland, because everything was already in place on native soil: an America that had always existed and that combined primitivism and modernism in a totally original way. There was no looking towards a past of European origin: the new architectural and decorative lines tended to exploit the indigenous, that is to say, that complex of decorative motifs derived from native American art. Together with a manneristic Egypt which is on display primarily in the movies and in the movie houses of Los Angeles, we find, even if not always clearly distinguished, motifs, symbols, and other representations associated with various native American peoples.

* * *

As we shall see in more detail in the course of our journey, there are certain symbolical forms or matrices which constantly recur in the construction or in the decoration of both interiors and exteriors of Deco structures. Among them are the fan shape, vegetal elements like lotus flowers, trees and leaves, the frozen fountain as symbol of life, with jets of falling water from which emerge other figures: Prometheus, sirens, Venuses, stylized animals and flowers. Many of these elements can be found in the gleaming, copper-colored terra cotta Frozen Fountain which adorns the entrance of the Wolfsonian Foundation in Miami Beach, [27]having been moved from its original location in the Norris Theater in Norristown, Pennsylvania. As in several other Deco ornaments, it features a mixture of elements both natural and mythical, exotic and indigenous, where, needless to say, the artificial dominates, while nature and history disappear, only to be reinvented by the imagination.

The dominant form for buildings, from the massing of skyscraper towers to the facades of the low-profile movie houses, was that of the stepped or terraced pyramid, variously considered to be of cubist, Babylonian (hence the term "ziggurat") or Mayan inspiration. In fact, an important consideration, at least in the case of the skyscrapers, was not stylistic but practical, namely a response to zoning restrictions — notably the New York zoning law of 1916 — which required setbacks in order to insure the access of natural light to the streets, which might otherwise be in permanent shadow.

Another important stylistic innovation, introduced during the thirties, was the flowing, aerodynamic look known as streamlining.[28] Because it was created by using materials which were both inexpensive and of striking appearance (such as black enamel, plastic, and aluminum), it was suitable not only for more modest edifices, such as the by now classic diners so typical of industrial art, but also for much larger structures, like the Coca Cola bottling plant in Los Angeles or, the most important of all, the Guggenheim Museum in New York, one of the last buildings of this type (1946-1959). Here Wright employed the archetypal figure of the spiral to give the structure a dynamic, circular movement and to lighten its material solidity.

Private residences fit into a separate category, especially the homes designed by Wright in his California phase, and those on the hills above Los Angeles — the westernmost outpost of the International Style — designed by such expatriates as Neutra and Schindler, Davidson and Peters. Construction materials varied, but cement, iron, glass, and steel were predominant, due to their functionality and low cost. In applying decoration, these architects made

equal use of both common materials and costly ones, and they did so with great variety and expressive freedom: tile, stucco, plaster, wrought iron, steel, aluminum, glass, and precious and native woods. Many common structural and decorative elements — elevator doors, radiator grills, mail boxes, marquetry panels — were embellished with similar design motifs, underscoring a close tie between the exterior and the interior of the buildings.

Colors: with the exception of the facades of movie houses in the Mayan style, and the countless shades of pastel in Miami Beach, which is a separate case, the dominant colors were beige, black, steel, silver, Tango (a dark orange), brown, and Pompeian red.

An appendix to classic Art Deco — appendix not only geographically but chronologically, since it remained in favor until the forties — was the so-called "Tropical Deco," which "flowered" in Miami Beach. In this tropical region, geometric yet full-bodied forms and bright colors were particularly suited to the environment and to the surrounding landscape. There was no trace of naturalism, which was absent from here and from all Deco worthy of the name, where, as a matter of principle, the artificial reigns supreme.

Here, art was used primarily in the decoration of apartment buildings and hotels which catered to a relatively affluent middle class in search of tranquillity and sunshine, but unable to afford the more extravagant resort of Palm Beach. Barbara Capitman must be given credit for recognizing the value of the splendid Deco district.

The oscillations of taste, as Gillo Dorfles would say, and the associated idea of the revival are recurrent phenomena, and objects of particular interest in our post-modern condition. In recent years, the Deco style has witnessed not only a wave of renewed interest on the part of scholars of art and culture, but has enjoyed (and is still enjoying) a season of popularity in design, graphic arts, interior decoration, and in the design of spaces for public entertainment, facilitated by a special interest in second-hand objects with a "modernistic" flair. In the course of our journey we will be able to refer only briefly to this phenomenon which certainly would merit more careful consideration.

Cinema both reflects and creates the splendor of architecture. In Hollywood they used to say "Every man and every woman is a star," and the glittering screen stars were the ones who helped to spread the American illusion of an unchangeable and carefree youthfulness. In the movies of those years, the representation of life as light, pleasant, and tinged with irony found its most refreshing expression in the so-called screwball comedies of Frank Capra and Ernst Lubitsch. *It Happened One Night* (1934) with Clark Gable and Claudette Colbert turned Frank Capra into a celebrity. His optimistic vision of the middle class, crossed by a vein of wry anti-conformism, seemed to coincide perfectly with the taste and expectations of the American public. Capra was also successful in mining the widespread feeling of hope and assurance typical of the New Deal with movies such as *Mr.*

Bitter Tea of General Yen, dir. Frank Capra, 1933, starring Nils Ashter and Barbara Stanwick*.

Deeds Goes to Town (1936), *You Can't Take it with You* (1938), and *Mr. Smith Goes to Washington* (1939).

Ernst Lubitsch produced ingenious and sophisticated expressions of light comedy with *Trouble in Paradise, If I had a Million* (1932), *The Merry Widow* (1934), where Jeannette McDonald and Maurice Chevalier trilled and warbled their way across the screen, with *Bluebeard's Eighth Wife* (1938), and finally with *Ninotchka* (1939), where, as the successful slogan proclaimed, even "Garbo laughs."

In 1929, the year of the great crash, movies seemed to want to exorcise all the phantoms of those dark days by embarking upon the extraordinary adventure of the sound track. People sang and danced in the movies, giving rise to that tradition of musical comedy whose fame has never diminished. To the rhythm of the tap dance and the popular song, the splendors of the musical accompanied the careers of two exceptional singers and dancers: Ginger Rogers and Fred Astaire. The fact that Ginger and Fred were destined for glory in the world of show business became obvious from 1933 to 1937 in an exciting series of musicals, such as *Flying down to Rio, Roberta, Top Hat, Swing Time, Follow the Fleet*, and *Shall we Dance*. In the latter, with a musical score by George and Ira Gershwin, Fred Astaire appeared in a sequence which has remained famous in the history of the genre. In

Night Club Lady, dir. Irving Cummings, 1932, starring A. Menjou, Mayo Methot and Skeets Gallagher*.

Platinum Blonde, dir. Frank Capra, 1931, starring Jean Harlow*.

the typical and topical setting of the transatlantic steamer, Fred dances to the rhythm of the ship's machinery. Irving Berlin, the other great king of musicals, once remarked to George Gershwin: "There is no setup in Hollywood that can compare with doing an Astaire picture" (Mueller, 9). The films are also notable for their very often astonishing examples of Art Deco décor.

It was with Busby Berkeley, a true master of originality and imagination, that the musical genre reached the height of its success. His memorable choreography created tableaux vivants on a grand scale, animated by hundreds of dancers moving in spectacular and always different configurations. The audience marveled at the scenographic inclusion of everyday objects, also of contemporary design, such as typewriters or telephones, made larger than life, in the whole and in detail, with playful stage and camera tricks. As Piero Pruzzo notes in a recent book, these were "impressive extravaganzas, sometimes oneiric, sometime hyper-realistic" (Pruzzo, 12).

As many cultural historians have remarked, Berkeley's films were a triumph of the "marvellous" and the kitsch. But perhaps even more surprising was the innovation of showing on screen all the tricks and hidden mechanisms which went on backstage. The mechanism *of* cinema, like

a tale within a tale, was thus represented as a mechanism *in* cinema. Berkeley's *Gold Diggers of '35* recounted the adventures of the lovable and slightly cynical money hunters who were characteristic of the thirties. Franco La Polla writes that "For a good portion of the thirties, the movies directed and/or choreographed by Berkeley depicted the confrontation of two worlds, the world of entertainment and the world of the privileged class. The films invariably ended in reconciliation, but in the process, succeeded in translating onto the screen the talent, the will, and the relaxed congeniality which characterized the show business scene, which in turn represented, more or less officially in his movies, an America ruined by the economic crisis" (La Polla, 51).

Audiences were enchanted by the bubbly and sophisticated wit of contemporary comedies, and by the mysterious charms of Mata Hari (played on the screen by Greta Garbo in 1931), femme fatale in both show business and politics.

At the same time, the dream of grandeur and magnificence was perpetuated in movies such as Cecil B. De Mille's *Cleopatra* (1934), in which a seductive Claudette Colbert wandered among buildings of a manneristic Egypt, a style which, precisely because of its geometric grandiosity, seems closest to Deco. In 1922, the discovery of the tomb of Tutankhamen, popularly renamed King Tut, had caused a sensation, and gave rise to a fad for things Egyptian which reached the movie capital. The first important movie house built in Hollywood dates from this period. It was the Egyptian Theatre, designed by Meyer and Holler, who drew inspiration directly from the king's tomb.

Grandeur and luxury also ruled the life and the ideas of William Randolph Hearst — made immortal by Orson Welles in his *Citizen Kane* (1941) — a man of substantial fortune, owner of a chain of newspapers and magazines, art collector, and movie producer. In the years when the great Chaplin astounded the public with his talent and with his scandalous affairs with an almost unlimited number of very young beauties, Hearst placed his name and his lifestyle before the public through his extravagant luxury and eccentricities. In 1919, at San Simeon on the Pacific coast, Hearst had built for himself a sumptuous mansion which he called *Cuesta encantada*, a real castle filled with art treasures, which he used as a weekend retreat.

Mach mich Glucklisch, dir. Arthur Robinson, 1935*.

His fabulous cocktail parties were attended by everybody who was anybody in Hollywood to honor the master of the house and his mistress, the charming Marion Davies, who was spoken about with adulation — in Hearst's newspapers of course — as the greatest miracle cinema had ever witnessed. For her and for her glory, Hearst even founded a movie enterprise, Cosmopolitan Productions.

It was also the epoch of the trend-setting, platinum blonde vamp, from Clara Bow, known after 1926 as "the hottest jazz baby in films," to the ill-fated Jean Harlow; from Carole Lombard, Clark Gable's unforgettable love, to Mae West who, with her biting wit and opulent figure, seemed to dispel the very idea of an economic crisis.

Several of those heroes and heroines were plagued by scandals. No one forgot the sensation caused by Roscoe "Fatty" Arbuckle who, after drinking heavily at a Hollywood "orgy," was said to have caused the death of a young starlet in 1921. And a wave of gossip swept through movie circles and newspapers at the revelation that, no matter how paradoxical it might seem, the first and second wives of Rudolph Valentino, Jean Acker and Natasha Rambova, were both lesbians. They had both become the protégées of another lesbian actress, Alla Nazimova, one of the most remarkable of Hollywood's acquisitions. From her mansion on Sunset Boulevard,

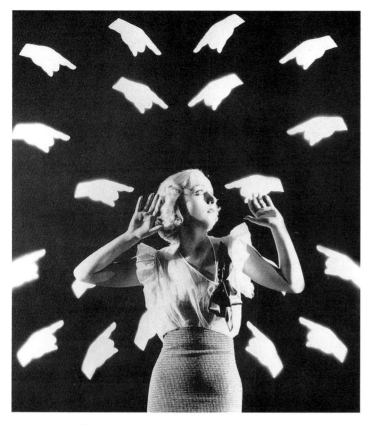

Virtue, dir. Eddie Buzzell, 1932, starring Carole Lombard*.

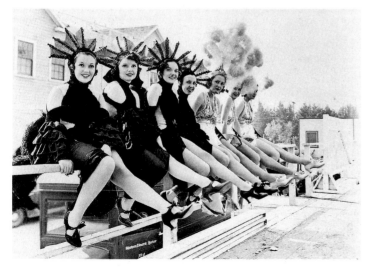

Women of Glamour, dir. Wise Gordon, 1937, starring Virginia Bruce and Melvyn Douglas*.

called, in an echo of her own name, "The Garden of Allah," she lavished her bohemian taste and her passion for the exotic. It was as if Hollywood were enveloped by an aura of paganism in which rites of the most unbridled worldliness were consummated. Amidst sex, alcohol and drugs, that beautiful and damned world found its sublimation on the screen, captivating millions of delirious spectators.

In 1928, almost as if to counter the climate of excess and perversion, a character from Walt Disney's magic pencil, destined for sure and worldwide fame, appeared on the screen: Mickey Mouse. This small, virtuous, and fearless cartoon creature was a mirror of American middle-class ideals. And sometime later, the once and future Disneyland would offer a model of what might be called narrative architecture, that is, architecture as a timeless three-dimensional tale. In fact, the Disneyland of today is an architectural extravaganza, a 'real' dream-world where traditional forms have been revisited and transformed by the imagination. "Architecture always has the power of transporting us to 'other' realms", writes Beth Dunlop, while underscoring the typically American idea "that the world can be made perfect, if only in fiction".[29]

So it was that the movies told a beautiful tale, and audiences willingly let themselves be carried away by a glittering world of a thousand perversions and chaste respectability, of beauty and elegance that seemed to transcend even the laws of time and space. Between the screen and the audience there was a continuous interplay, a fascinating game of mirrors which sustained the illusion that the screen images were a perfect imitation of life, and that life was nothing but a reflection of the stories told. The world of the stars became a myth and the audiences identified with it: everyone seemed to be both dreaming movies and dreaming at the movies.

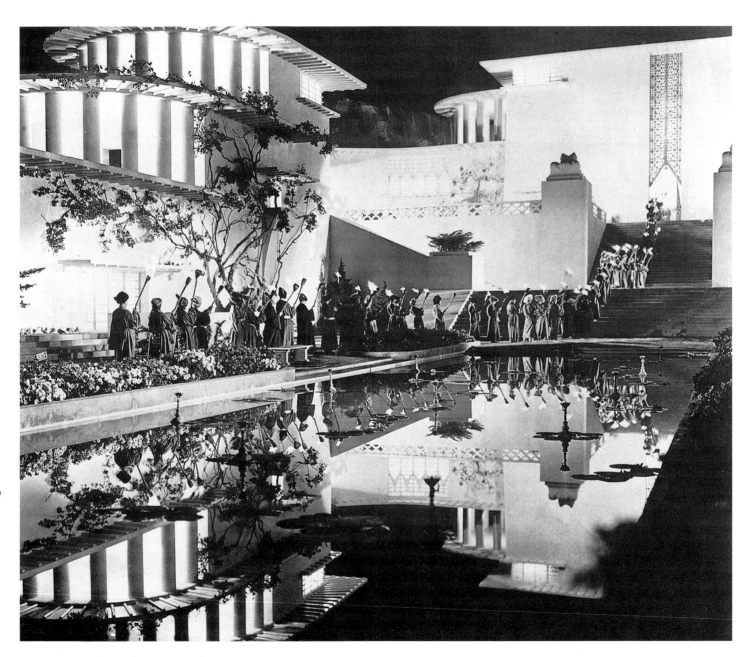

Lost Horizon, dir. Frank Capra, 1937*.

DESTINATIONS
CHICAGO

To speak of Chicago architecture is to speak of American architecture. It is no accident therefore that we start our journey in this city, which can be considered to be the cradle of Art Deco architecture. But Chicago — home of the "Chicago School" which includes such great masters as Louis Sullivan, Daniel H. Burnham, and Frank Lloyd Wright, and the place where H.H. Richardson too left his imprint with the Marshall Field Wholesale Store (now demolished) and the Glessner House — is the city which is the first to launch new trends and the first to abandon them, thus embodying that "new tradition" which the critic Henry-Russell Hitchcock had already identified in 1929 in his seminal *Modern Architecture: Romanticism and Reintegration.*

Traces of all the architectural styles can be found in Chicago, and the most illustrious names in architecture have worked there. Not the least of these were the great European émigré architects, who contributed new forms to a multicultural movement which left a determining mark on the America of the so-called "machine age." And if it is true that, with the arrival in 1938 of Ludwig Mies van der Rohe as director of the Architecture School of the Armour Institute (now the Illinois Institute of Technology), the essential and spare line of the International Style became predominant, it is also true that — as one Art Deco aficionado put it — "Chicago has a lot of cautious Art Deco."[30]

Although New York is the "city of skyscrapers" par excellence, the skyscraper was born in Chicago. As already mentioned, the winner of the famous competition in 1922 to design a new home for the *Chicago Tribune* was the building by Howells and Hood that, with its decorations and pinnacles reminiscent of the gothic style, evoked the past rather than heralded the future. But it was the modernism of Eliel Saarinen's second-place design which announced a new direction in architecture, both in Chicago and in other American cities. A fresh spirit was born, a new type of "poetry in architecture," where — in keeping with Sullivan's famous dictum — form follows function.

Chicago, then, was the cradle not only of American architecture in general, but of the last "total" architecture, namely Art Deco, which it glorified in the World's Fair of 1933, renewing the pomp of the World's Columbian Exposition of 1893. Many of the most important architects and designers of the time, including Daniel H. Burnham Jr., Norman Bel Geddes, John A. Holabird and John Wellborn Root, Albert Kahn, and Joseph Urban, participated in it. Urban, the Director of Color Coordination, was responsible for the particularly effective and dramatic use of color and light to ornament and unify the site (Duncan, 259). And many other architects and designers came to visit, carrying ideas and suggestions away to the rest of the country.

In the spirit of the age, the Exposition was called — and it could not have been otherwise — "A Century of Progress." As was the case with many other fairs and expositions which took place in the twenties and thirties, most of the structures which were built for 1933 Exposition were quickly demolished. But a few buildings were saved from oblivion, rescued and transported elsewhere, like the seven model homes in futuristic style which are now located in the Indiana Dunes National Lake Shore Recreation Area. Perhaps the most interesting of these — a circular construction in steel and glass on three receding levels designed by the Keck Brothers — was called, characteristically, "House of Tomorrow."

Today, Chicago remains a major attraction for lovers of architecture, both for what it has preserved, and for what it has taught and continues to teach. It is not by chance that the Chicago Art Deco Society (CADS) — whose founding was encouraged by Art Deco revival champions Barbara Capitman, a Chicago native, and Leonard Horowitz — is one of the oldest associations for the study and preservation of Art Deco in the United States.

In the northern part of the city, close to the shore of Lake Michigan, is the Madonna della Strada Chapel, designed by Andrew Rebori and built in 1938-39 on the campus of Loyola University, site of the same architect's Cudahy Library of 1930. At first sight, the structure looks distinctly

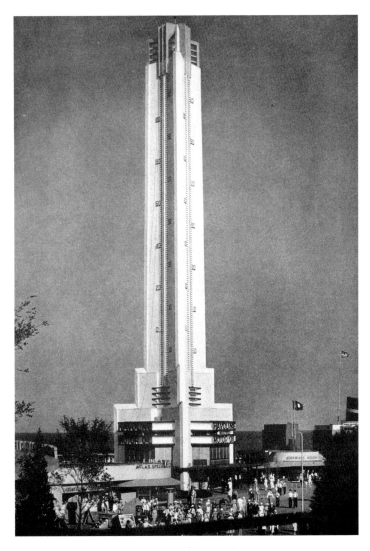

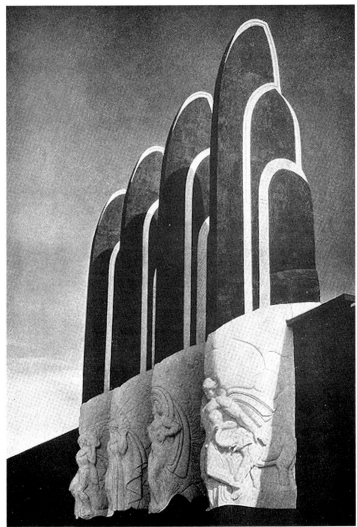

Chicago, The Havoline Thermometer, (now demolished), from the *Official Pictures of a Century of Progress Exposition, 1933**.

Chicago, The Pylons on the Hall of Social Science, (now demolished), from the *Official Pictures of a Century of Progress Exposition, 1933**.

Romanesque, with its large rose window on the upper part of the facade, and the tall rounded windows on the side, separated by fluted piers. The real surprise is the apse, formed by a series of concentric arches recalling Radio City Music Hall and the Hollywood Bowl, among others. More than the traditional campanile, the church tower evokes the elegant, slender shape of contemporary skyscrapers. The Deco linearity is underscored by the restrained, geometric decoration consisting primarily of incised lines and chevrons, and fluting.

Moving from one kind of temple to another, we go from the realm of spirituality to the realm of business and commerce. Sears, Roebuck and Company, having created a business model with its pioneering catalog, also provided a model of architectural design. The original Sears store, designed by the Chicago firm of Nimmons,

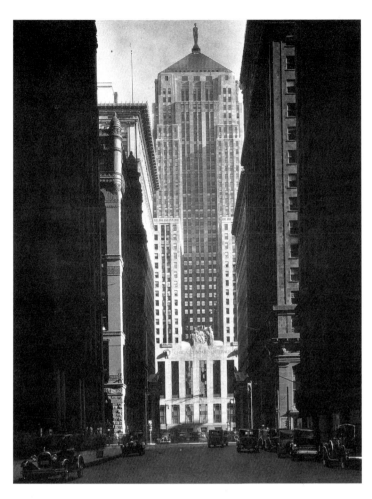

Chicago, Chicago Board of Trade Building, 141 W. Jackson Blvd. (J. A. Holabird and J. W. Root, Jr., 1930)*.

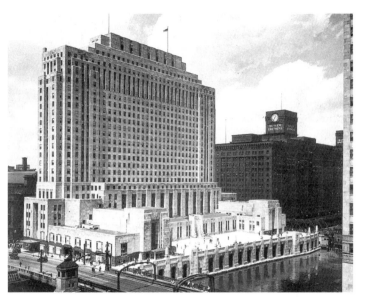

Chicago, Chicago Daily News Building, 400 W. Madison St. (J. A. Holabird and J. W. Root, 1929)*.

Carr, and Wright, was characterized by an elegant tower embellished with Art Deco motifs and topped by an illuminated Sears logo. This prototype was exported to many parts of the country, though only a few are still standing today, notably in Boston and Miami.

The Chicago Board of Trade Building was considered one of the best Deco skyscrapers in the city until its structure was extensively altered in 1980. The original building had been designed in 1930 by Holabird and Root, one of the most prestigious firms of that period. The new addition is unabashedly post-modern, but is successfully grafted on to the earlier building through the use of the same

pyramidal top. The interior of the original structure is pure Deco, producing a stunning effect through the inventive use of diverse materials, such as marble and glass, as well as glass panels running from ceiling to floor and lit from the back, a typical Deco device.

By the end of the twenties, Chicago was rich in tall skyscrapers and other imposing buildings created by a veritable dynasty of brilliant architects. John A. Holabird and John Wellborn Root, Jr., who, in addition to the just-mentioned Chicago Board of Trade, designed a number of other buildings we will visit on our tour — such as the Palmolive Building and the Chicago Daily News Building — were themselves the sons of two leading architects of the Chicago School, and they repeated the success of their fathers.

Among their most representative projects, the Palmolive Building — later the Playboy Building and now 919 North Michigan Avenue — begun in 1927 and completed in 1929, displays a ziggurat structure whose upward thrust is accentuated by vertical bays and windows. This building, topped by the powerful Lindbergh Light, was for a long time the symbol of nocturnal Chicago until the play of its far-reaching beam was obstructed in the direction of the

Loop by the construction, in the late 60's, of a neighboring, and taller, building.

Just west of the Loop, stands another Holabird and Root design, the Chicago Daily News Building (now Riverside Plaza; 1929). The geometric symmetry of the facade is supported by a row of piers at the base. The motif of piers is taken up at both ends of the building, while the vertical bands on the facade counter balance the horizontality of the design. The top floors are set back, recalling the ziggurat motif. The ornamentation of the building incorporates several Deco features: a mural by John Norton in the main corridor, dedicated to the glories of the printing press; an outside fountain with reliefs by Alvin W. Meyer; and the elevator doors, particularly elegant in their simple and sober structure, and topped by decorations bearing a clear by Deco imprint. As we shall see even more clearly in New York, the attention to detail in the decoration of lobbies and corridors in both office and apartment buildings extends to the most common elements, thereby creating a sense of continuity between the exterior and the interior.

Across the river from the Daily News Building is the imposing Civic Opera Building, which presented a considerable engineering challenge to the firm of Graham, Anderson, Probst, and White (G.A.P.& W.). Completed in 1929, the base of the building contains a 3500 seat opera house and a smaller theater. Above this hollow space, an office tower rises unbroken on one facade and with a sharp setback on the other. An impressive colonnade covers the sidewalk on east side and provides access to the theaters. The building is graced with Renaissance, Deco, and musical motifs.

The same firm designed both the Field Building (1928-34; now LaSalle National Bank Building), and the Merchandise Mart (1927-1931), which was, until a short time ago, the largest commercial building in the world. Its massive, imposing facade is composed of two symmetrical wings which flank a central tower, slightly higher than the rest of the building, and rising in subtle steps to a pyramidal roof.

The severity of the edifice is lightened by the characteristic vertical piers and recessed window bands, and by the discreet use, both inside and out, of decorations of the Mayan type, including triangular motifs and representations of arcs and arrows. (In 1945, the

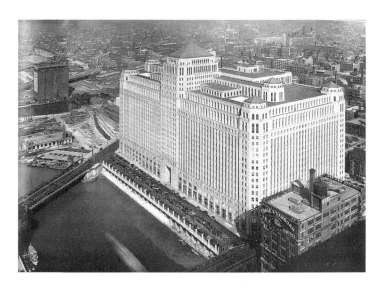

Chicago, Merchandise Mart, north bank of the Chicago River between Wells and Franklin Sts. (Graham, Anderson, Probst and White, 1927-31).

building was purchased by Joseph P. Kennedy, and it is still owned by the Kennedy family.)

The Carbide and Carbon Tower, built in 1929 by the Burnham Brothers firm, pioneered the use of colored terra cotta in Chicago with the dark green and gold sheathing of its shaft and its glistening gold-leaf trimmed pinnacle.

This austere structure has a base of polished granite, and an entrance hall decorated with black marble and bronze trim. Dating from the same year are the terra cotta decorations of the Laramie State Bank, whose ornamental motifs include a series of coins: at the time, a homage to wealth, but later, an ironic souvenir of the giddy days before the crash. This was the epoch of the great use of terra cotta tiles on a national scale, leading to the formation of numerous companies specializing in their production, such as Chicago's Northwestern Terra Cotta Company.

Of another order is the Esquire Theater (now Esquire Center), a late example of the phantasmagoric "movieland" style. Built in 1938 by William Pereira, only the exterior preserves the original Deco style, the interior having been converted into a multiplex cinema. The facade, extending on both sides of the entrance, which is dominated by a classic marquee and a towering vertical sign, can be described as transitional between Deco and

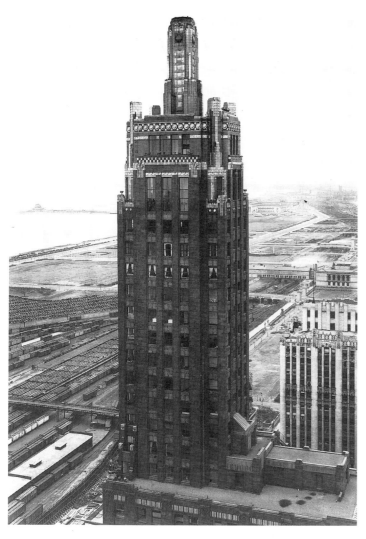

Chicago, Carbide and Carbon Building, 230 N. Michigan Ave. (Burnham Brothers, 1929)*.

the International Style, particularly in the curvilinear movement of the side wings, which are punctuated by engaged, fluted columns.

At some distance from downtown Chicago, in the suburb of Oak Park, can be found some innovative structures which set the stage for Art Deco in America, namely, Frank Lloyd Wright's studio, and his Unity Temple, which the architect completed after his return from Japan. Some scholars might question Wright's relationship to Art Deco, but in our discourse on an age and its aesthetics, Wright's influence is a determining factor. Even the Prairie House style can be seen as having a role in the evolution of a school and of a tendency towards modernism and Deco. Also in Oak Park are the Deco style Lake Theater (1936) by Thomas Lamb, and a Marshall Field Store by the aforementioned firm of G.A.P.&W.

Among masterpieces now lost, we should mention the famous Midway Gardens, a "pleasure garden" or entertainment complex designed by Wright with the collaboration of Alfonso Iannelli. A true precursor of Art Deco, it was built in 1914, and demolished in 1929. All that survives today are a number of statues known as "Sprites", which were designed by Wright for the complex, and sculpted by Iannelli. Some of them now decorate the gardens of the famous Arizona Biltmore Hotel in Phoenix, a later stop in our itinerary.

We can end our visit to Chicago with dinner and entertainment in the Deco spirit. Arnie's Restaurant contains some window panels by Edgar Miller which have survived the demolition of the Diana Court of Holabird and Root. And after dinner we can attempt to bring back to life the Chicago of Al Capone by stopping to listen to music at the Green Mill, a jazz club that goes back to 1920. In the era of the famous gangster it was one of his favorite speakeasies.

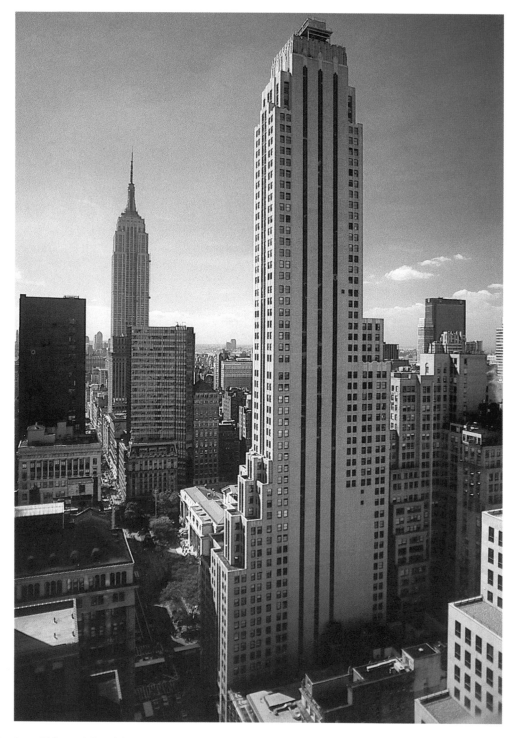

New York, Empire State Bldg. and 500 5th Ave. Building.

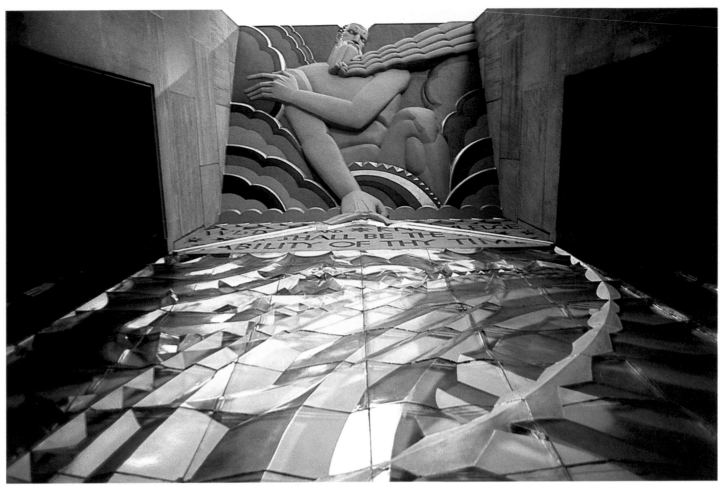

New York, Rockefeller Center, RCA (GE) Bldg., Rockefeller Plaza (R. Wood and Associated Architects, 1931-40), Wisdom (Lee Lawrie sculpt.), detail.

Joseph Urban, New York, "Central Park Casino", Ball Room mural, late '20s*.

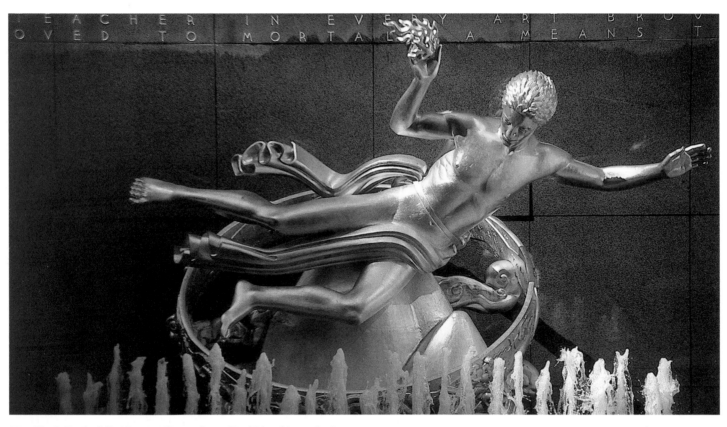

New York, Rockefeller Center, Prometheus (Paul Manship sculpt.).

New York, Rockefeller Center, Channel Gardens, detail.

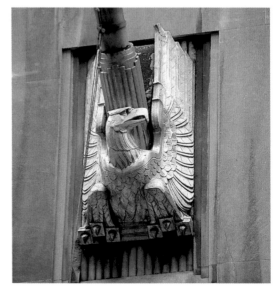

New York, The Waldorf-Astoria, 301 Park Ave. (Schultze and Weaver, 1930-31), detail.

New York, Rockefeller Center, Radio City Music Hall, detail.

New York, Rockefeller Center, Radio City Music Hall, detail.

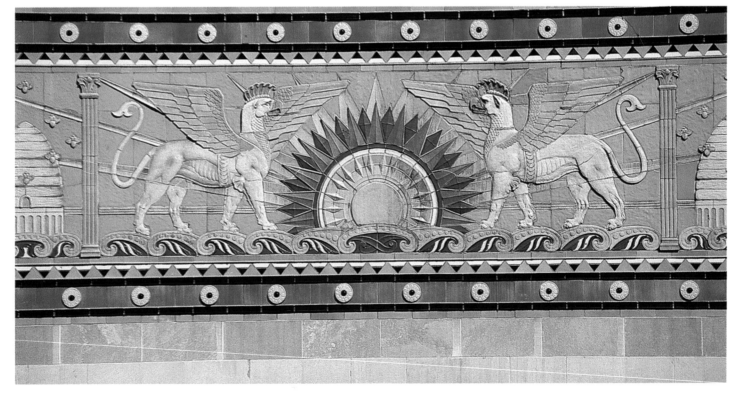

New York, Fred F. French Building, 551 5th Ave. (Fred F. French Co., 1927), detail.

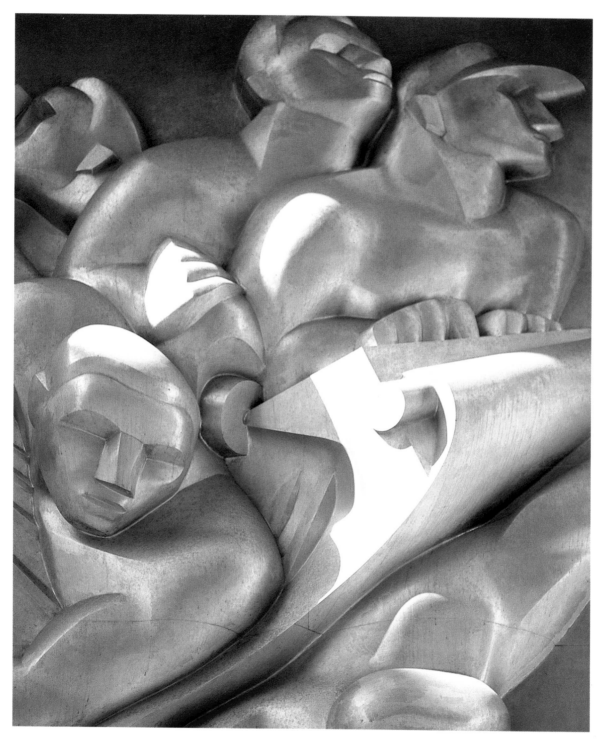

New York, Rockefeller Center, Associated Press Bldg. (Isanu Naguchi sculpt., 1938).

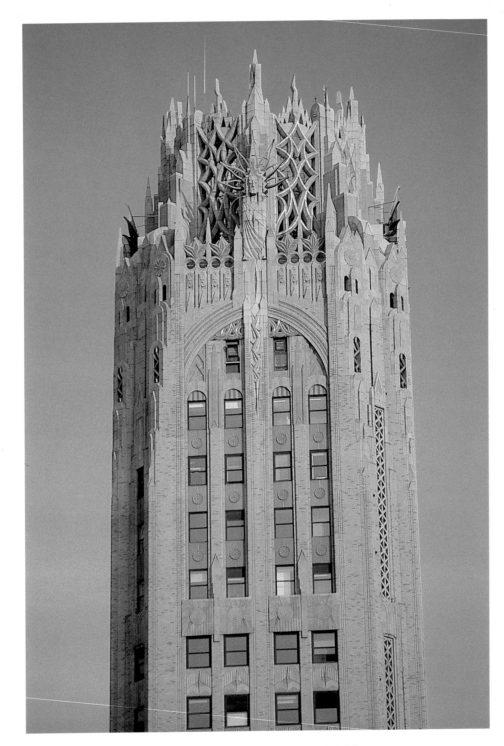

New York, General Electric Bldg., 570 Lexington Ave. at 51st St. (Cross and Cross, 1930-31).

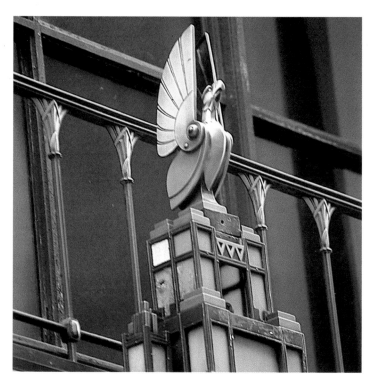

New York, Fuller Building, 41 East 57th St. at Madison Ave. (A. Stewart Walker and Leon Gillette, 1928-29, sculpt. Elie Nadelman), detail.

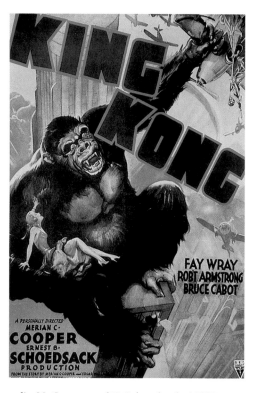

King Kong, dir. M. Cooper and E. Schoedsack, 1933*.

Gold Diggers of 1935, dir. and chor. Busby Berkeley, 1935, starring Dick Powell and Gloria Stuart*.

Cleopatra, dir. Cecil B. De Mille, 1934, starring Claudette Colbert (costume designer Travis Banton)*.

Denver, Paramount Theatre, 1631 Glenarm Pl. (Temple H. Buell, 1930), auditorium*.

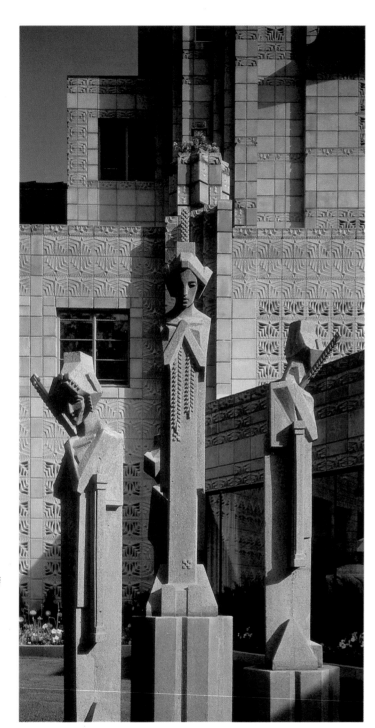

Phoenix, Arizona Biltmore, 24th Ave. at Missouri St. (Albert Chase Mc Arthur, 1929), "Sprites" by F. L. Wright and Alfonso Iannelli (1914)*.

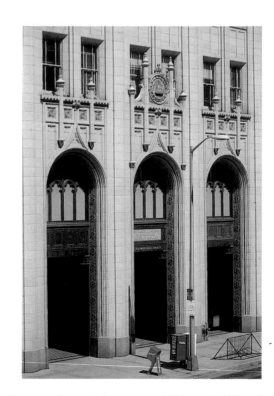

Denver, Mountain States Telephone and Telegraph Bldg., Curtis St. at 14th Ave. (William N. Bowman, 1929).

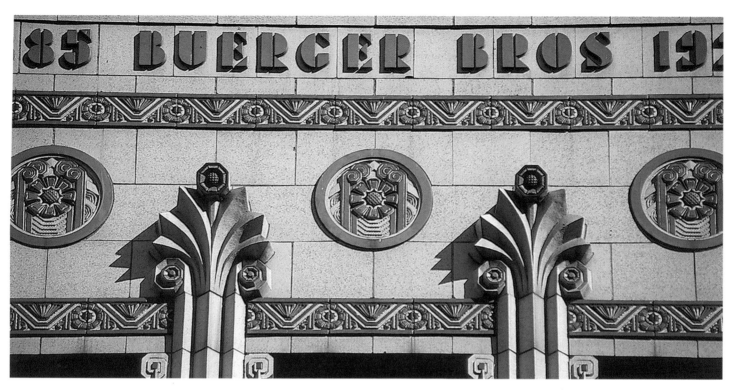

Denver, Buerger Brothers Bldg., 1732 Champa (Montana S. Fallis, 1929).

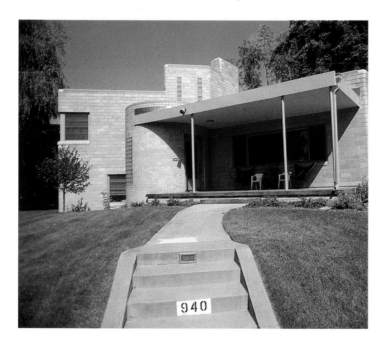

Denver, Private Home, 940 Bonnie Brae Blvd., 1938.

Boulder, L.A. Diner, 1955 28th St. (now demolished).

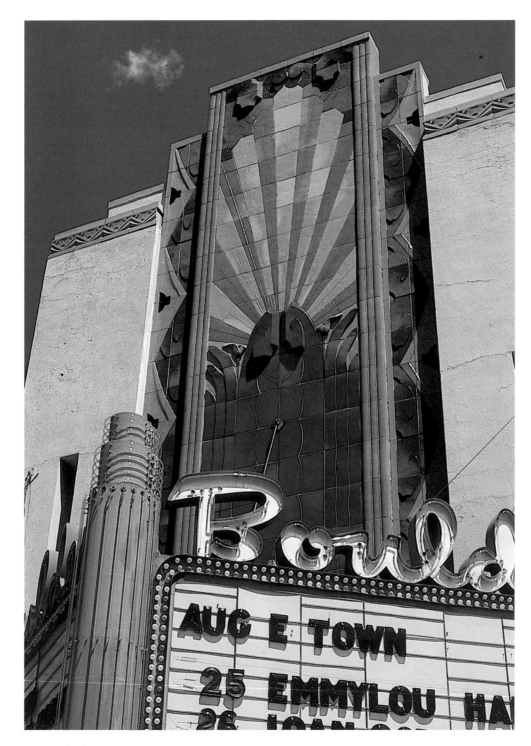

Boulder, Boulder Theater, 2034 14th St.

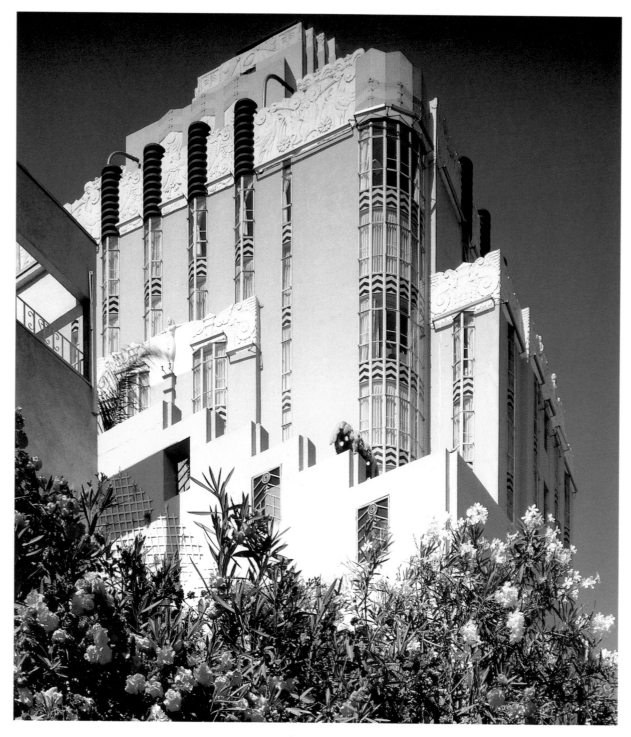

Los Angeles, Sunset Towers (later called St. James Club, and now The Argyle), 8358 Sunset Blvd. (Leland A. Bryant, 1929).

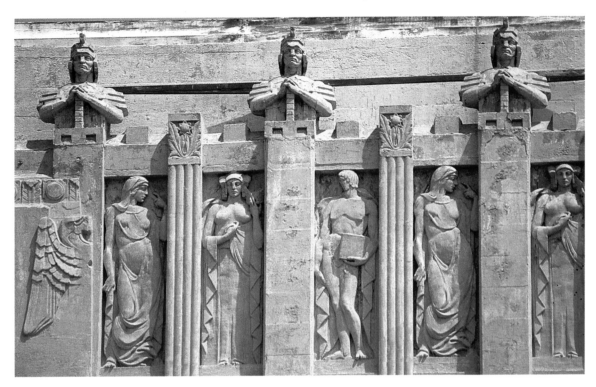

Los Angeles, Mountain States Life Insurance Bldg. (now Vine Tower Bldg.), 6305 Yucca at Vine (H. L. Gogerty, 1928), detail.

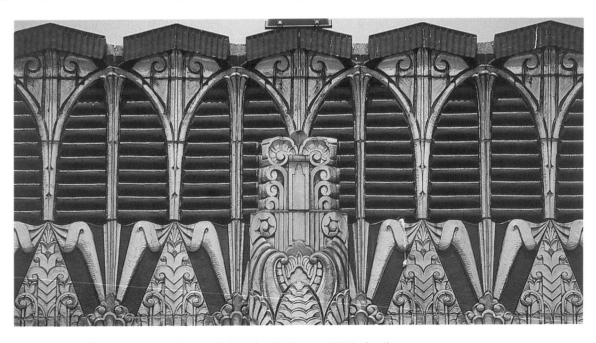

Los Angeles, Selig Building, 269 South Western Ave. at 3rd (Arthur E. Harvey, 1931), detail.

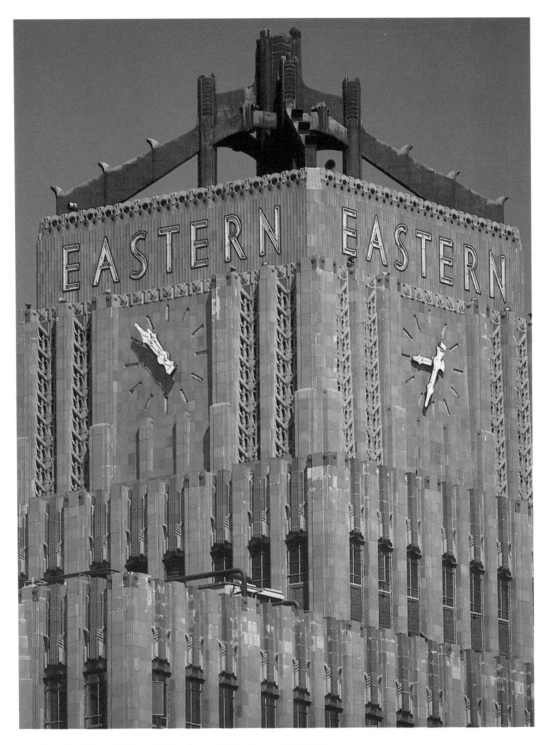

Los Angeles, Eastern Columbia Bldg., 849 South Broadway (C. Beelman, 1929-30).

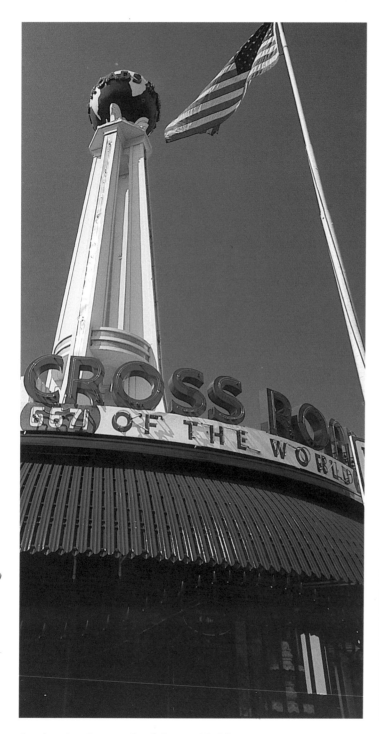

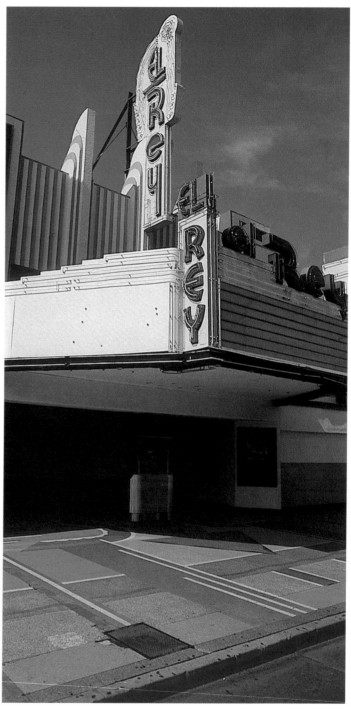

50

Los Angeles, Crossroads of the World, 6671 Sunset Blvd. (Robert V. Derrah, 1936).

Los Angeles, El Rey Theatre, 5519 Wilshire Blvd: (W. Clift Balch, 1928).

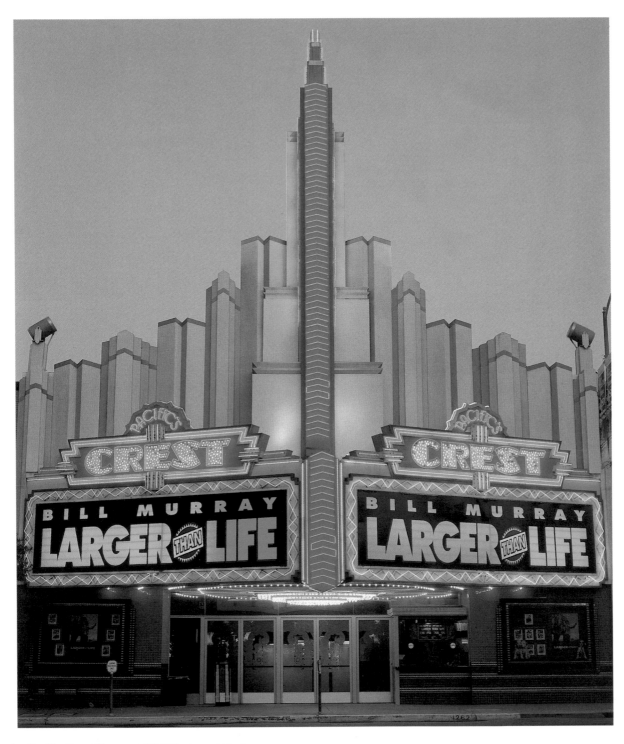

Los Angeles, Pacific Crest Theatre, 1262 Westwood Blvd.

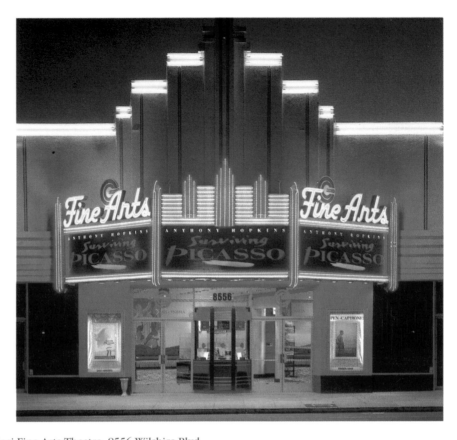

Los Angeles, AMC Cecchi Gori Fine Arts Theatre, 8556 Wilshire Blvd.

Los Angeles, Mann's Chinese Theatre, 6925, Hollywood Blvd. (Meyer and Holler, 1927).

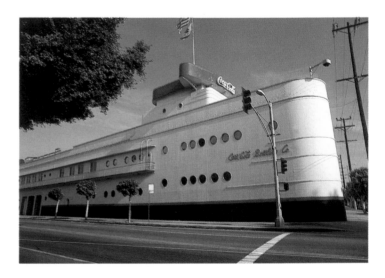

Los Angeles, Coca Cola Bottling Co. Bldg., 1334 South Central Ave. at 14th (Robert V. Derrah, 1935-37).

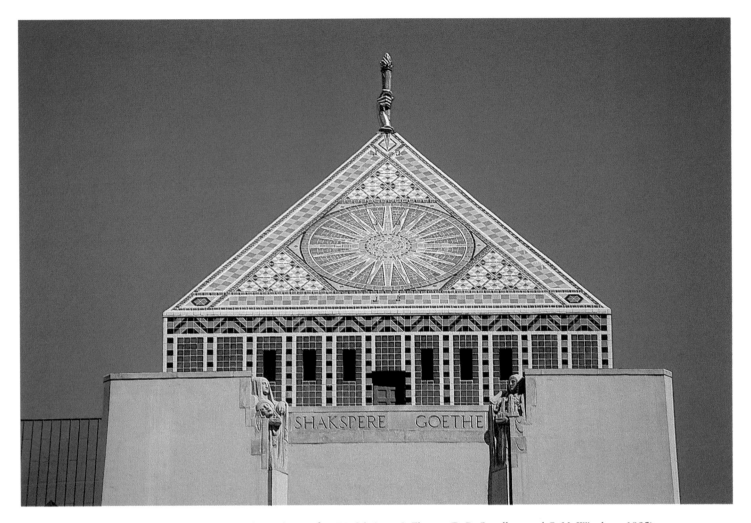

Los Angeles, The Central Library of the L.A. Public Library, 630 W. 5th St. at S. Flower (B. B. Goodhue and C. M. Winslow, 1925).

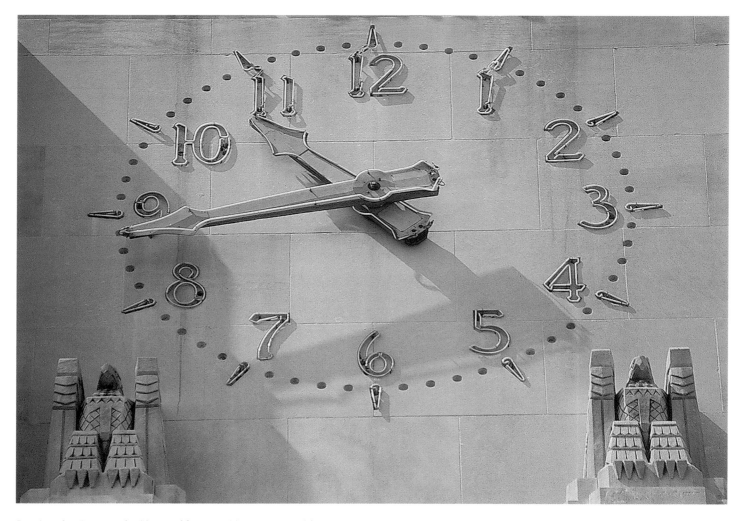

Los Angeles, Los Angeles Times Bldg. (now Times Mirror Bldg.), 202 W. 1st St at Spring (Gordon B. Kaufman, 1931-35), detail.

Los Angeles, Hollywood Bowl, 2301 N. Highland Ave. (Lloyd Wright, 1924-28, and Allied Architects, 1929-on; sculpt. George Stanley, 1935-40).

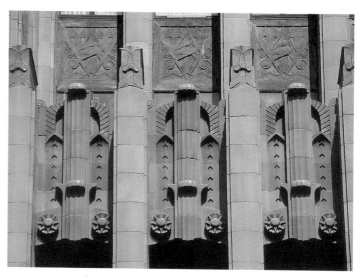

Los Angeles, Los Angeles Jewelry Center, 629 S. Hill St. (1930), detail.

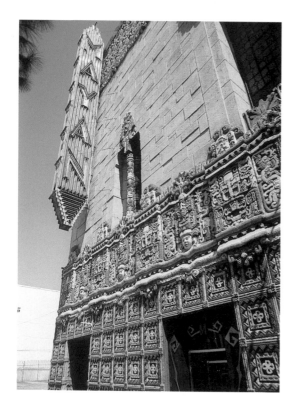

Los Angeles, Mayan Theatre, 1040 S. Hill St. (Morgan, Walls and Clements, 1927).

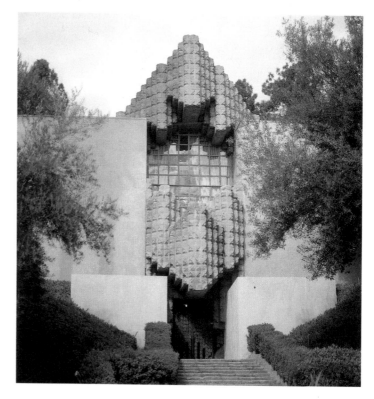

Los Angeles, Sowden House, 5121 Franklin at Normandie (Lloyd Wright, 1926).

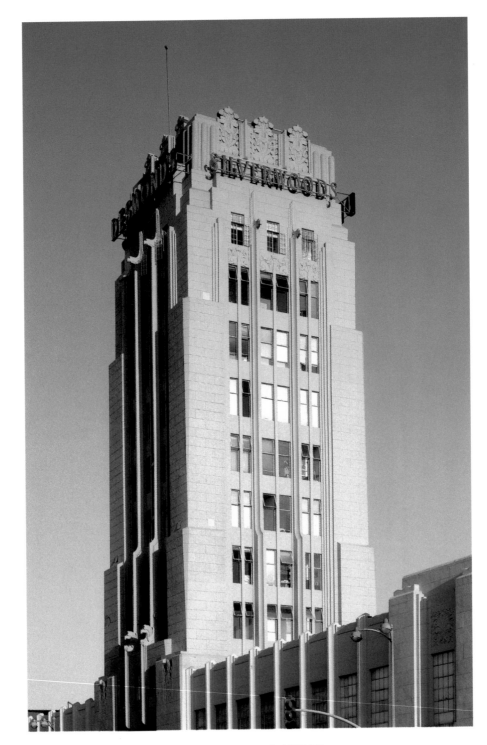

Los Angeles, Desmonds Building, 5514 Wilshire Blvd. (Gilbert St. Underwood, 1928-29).

Los Angeles, Griffith Observatory, 2800 Observatory Rd. (J. Austin and F. M. Ashley; sculpt. A. Garner, 1934-35), detail statues with Hollywood sign in background.

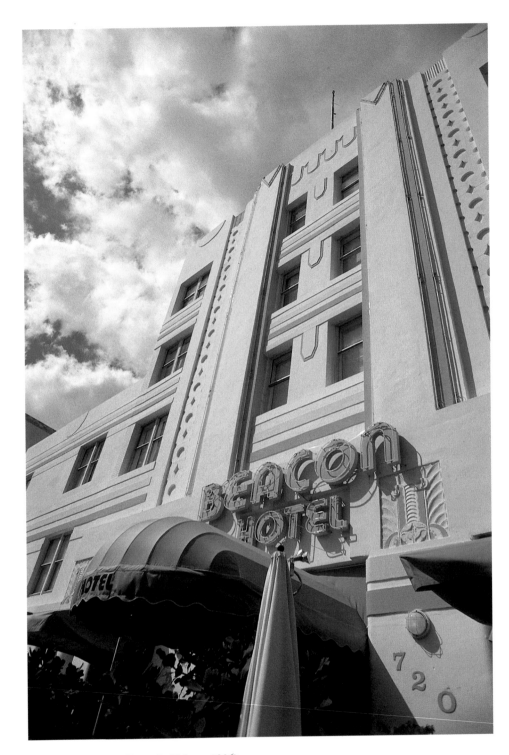

58

Miami Beach, Beacon Hotel, 720 Ocean Dr. (Harry O. Nelson, 1936).

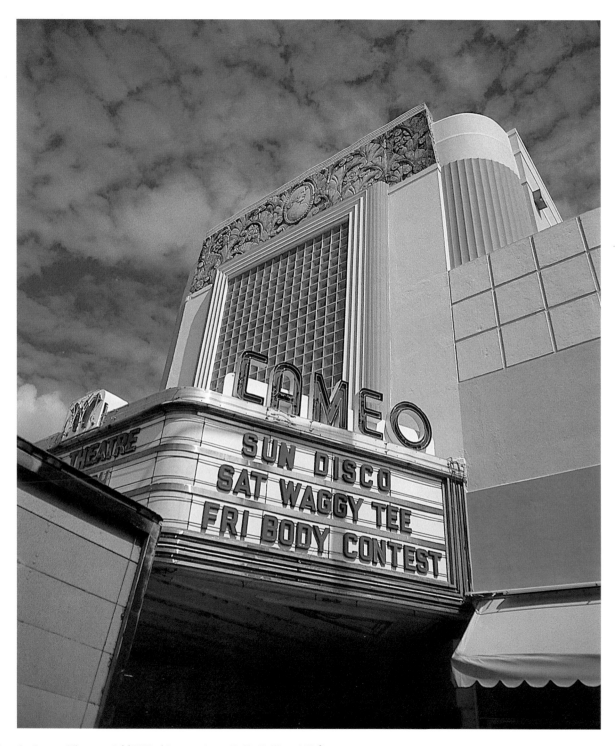

Miami Beach, Cameo Theatre, 1445 Washington Ave. (R. E. Collins, 1936).

Miami Beach, Helen Mar Apartments, 2421 Lake Pancoast Dr. (R. E. Collins, 1936).

Miami Beach, Abbey Hotel, 300 21st. (A. Anis, 1940), the flamingo.

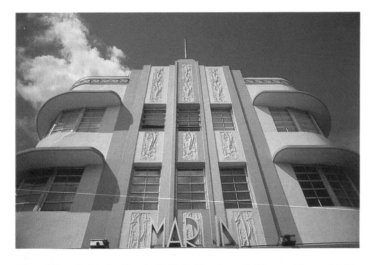

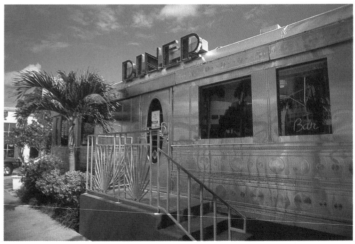

Miami Beach, Marlin Hotel, 1200 Collins Ave. (L. Murray Dixon, 1939).

Miami Beach, 11th St. Diner, 1065 Washington Ave.

NEW YORK

*"We lived there in the center of Manhattan...
No star was to be seen in the heavens, but the
sky was always bright with the flicker of
distant lights."*

Elizabeth Hardwick

For Truman Capote, New York is

...a myth, the city, the rooms and windows, the steam-spitting streets; for anyone, everyone, a different myth...This island, floating in river water like a diamond iceberg, call it New York, name it whatever you like; the name hardly matters because, entering from the greater reality of elsewhere, one is only in search of a city, a place to hide, to lose or discover oneself, to make a dream wherein you prove that perhaps after all you are not an ugly duckling, but wonderful, and worth of love.[31]

For others, New York is another Gomorrah, a doomed city; for still others, it is Jerusalem, a promised land, a magnificent apparition, a Noah's Ark, the beacon of liberty and of the new world, and at the same time a splendid catastrophe, a city of the past and of the future. In the eyes of Furio Colombo: "A Journey into vertical New York is a theatrical revelation"; John O'Hara called it "Baghdad on the Subway," while for Damon Runyon it was "the Big Apple." For us, it is the second stop on our journey, the *Mannahatta* of W. Whitman, the "city of spires and masts," unique for its skyscrapers and the unquestioned center of the Deco universe, due both to the large number of buildings in that style, and to their singularity, and high standards of taste. Elegance blends with effortlessness, making these towers of modernity ever more symbolic in their thrust upward.

Andy Warhol once commented to the photographer Reinhart Wolf: "Reinhart, these buildings make me think of money," to which Wolf, who has immortalized New York with superb images, retorted: "You are right. It is the good face of capitalism....The men who have erected Manhattan are the Medicis of America" (Wolf).

It is de rigueur to begin our tour with the Chrysler Building. Commissioned by the auto magnate Walter Chrysler, designed by William Alen and completed in 1930, it is the monument par excellence to the automobile and to the triumph of speed, a moderno-futuristic version of the medieval tower or campanile, soaring vertiginously to its daring spire, "the Vertex." The style has been called flamboyant Gothic, because of the modern-day gargoyles projecting from the four corners of the structure: streamlined eagles, emblems of American power, near the top of the main shaft, and, at its base, winged radiator caps, emblems of the power of the automobile industry. At the top is the signature dome with its bright stainless steel sheathing and distinctive structure of superimposed arches, which rises up like a minaret, standing out luminescent against the panorama of the surrounding buildings.

This theatricality and exaltation of dynamism is not limited to the exterior; it extends to the singular interior as well. One enters the building through monumental doors framed like proscenium arches. The main lobby, lavishly decorated in brown and black marble and illuminated with lights that evoke raised curtains, is a premier example of interior design as the mise en scène of business. The overall effect is that of a carefully choreographed show which might have been produced by Ziegfeld himself. As is the case with other Deco buildings, the elevators are given a distinctive design role through the use of eye-catching materials — here wood veneer and metal — and canonical Deco motifs, from drooping branches to upward-facing fans.

Facing the Chrysler from across 42nd Street, the lithe and powerful Chanin Building manages to hold its own. Designed by Sloan and Robertson, it was opened to the public in 1929 by the enterprising Irwin S. Chanin — contractor, impresario, theater producer and financier. It is a harmonious tower with the slab-like central part rising from a stepped back, pyramidal base, and topped by a crown of piers and buttresses. The decoration on the outside of the base includes a bronze freeze and a sheathing of terra cotta panels with elaborate floral and geometric motifs. But it is the inside which — in spite of numerous alterations — has the most interesting surprises in store. For example, at the entrance to the 52nd floor, where Chanin's private office was located, there is an admirable pair of bronze and wrought-iron gates, designed by René Paul Chambellan, whose decorative motifs incorporate wheels and mechanical gears, and

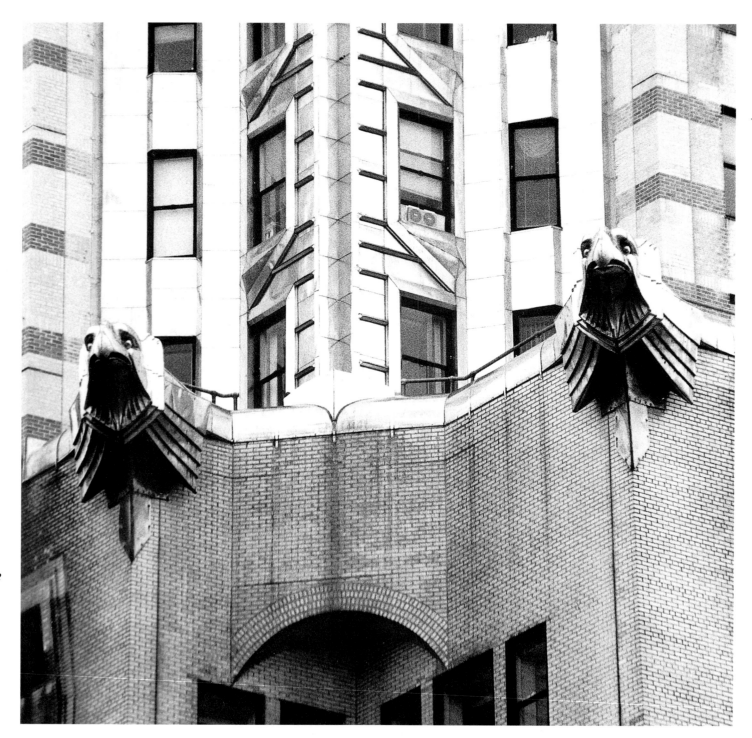

New York, Chrysler Building, exterior-detail.

symbolize the spirit of modern industry. These priceless pieces were included in the exhibition "The Machine Age in America" which was held in Brooklyn in 1986.

There are other remarkable decorative elements adorning the lobby and the Chanin Company offices, including the mail boxes, convector grilles, and the elevator doors. Of particular interest are the bronze reliefs celebrating the "City of Opportunity." The dominant colors, in contrast with the steel gray of the Chrysler building, are various shades of gold and brown.

Like the Chanin Building, the American Radiator Building (now the American Standard Building), built in 1924 on a design by Raymond Hood of Hood & Fouilhoux, was also inspired by Saarinen's famous drawings for the *Chicago Tribune* competition. Hood's building, at 40 West 40th Street, with its black brick silhouette topped by gilded pinnacles, evokes by night the image of a lit torch. It was the first Deco building in New York to be given landmark status, and it contributed to the fame of its creator, who was to become perhaps the quintessential architect of this period in the city. Writing about this building, the architect Harvey Wiley Corbett observed: "If commercialism is the guiding spirit of the age, the building which advertises itself is in harmony with that spirit....There is no reason why the term 'commercialism' should ever be considered as opposed to art." [32]

Another Chanin project, built by his firm between 1929 and 1930, is the Majestic Towers, an apartment building on Central Park, in which the geometric outline of the tower is decorated with volutes designed by René Chambellan and inspired by the expressionist architecture of the twenties.

But the building which appears most often on New York's publicity brochures, the very symbol of the "metropolis," is most certainly the Empire State Building. Designed by William Lamb of the firm Lamb, Shreve and Harmon in 1930, it has become the emblem of the city, visible from afar in a play of blinking lights as its beacon illuminates the surrounding buildings.

The architects, in keeping with the dictates of the "machine age," used only industrially produced materials and fittings. Thousands of people visit the Empire State Building daily, admiring the commemorative representation of the building itself, with the rays of the sun emanating from behind its spire, which dominates the lobby, and reliving the emotion of the fantastic and futuristic scenes of the movie *King Kong*. There isn't a

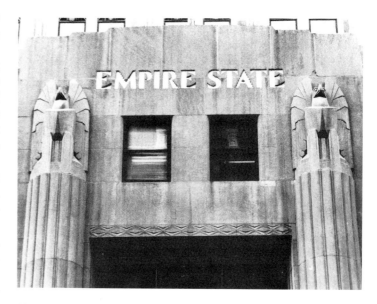

New York, Empire State Building, main entrance-detail.

tourist who doesn't want to feel the thrill and the vertigo of taking the speedy elevators to the top of the skyscraper which was, until recently, the tallest building in the world. The moving force behind the Empire State Building was John Raskob, a self-made man who reached the height of fame and fortune. He wanted this skyscraper to be the symbol both of his own success and of the general success of that great capital of business, the perfect model of an exemplary commercial building which would soon become the icon of the city.

Rockefeller Center is a true city within a city, an example of large-scale urban planning which includes a number of buildings, interior and exterior passageways, and even a private street, all opposite St. Patrick's Cathedral in the heart of New York. Originally occupying the area from 48th to 51st Streets between Fifth and Sixth Avenues, the Center today extends beyond those boundaries, but it is within its original limits that the most distinctive buildings are to be found.

In 1928, John D. Rockefeller, Jr., was attracted to a project for giving a new home to the Metropolitan Opera — a project with a strong civic and cultural focus which was to draw capital and support from many sources. These plans were upset by the crash of 1929, and the subsequent withdrawal of the Opera from the project. But

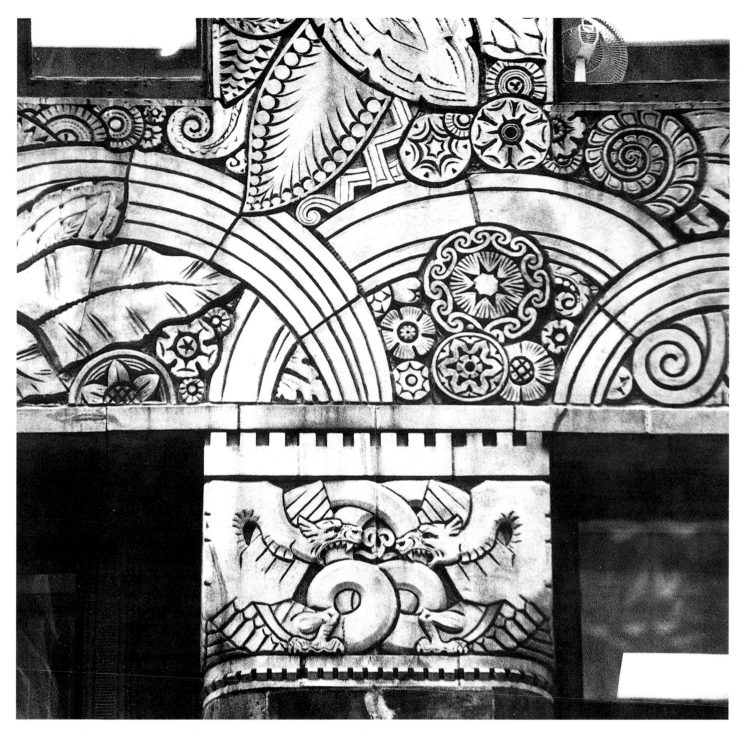

New York, Chanin Building, 122 E. 42nd St. at Lexington (Sloan and Robertson, 1927-29), exterior-detail.

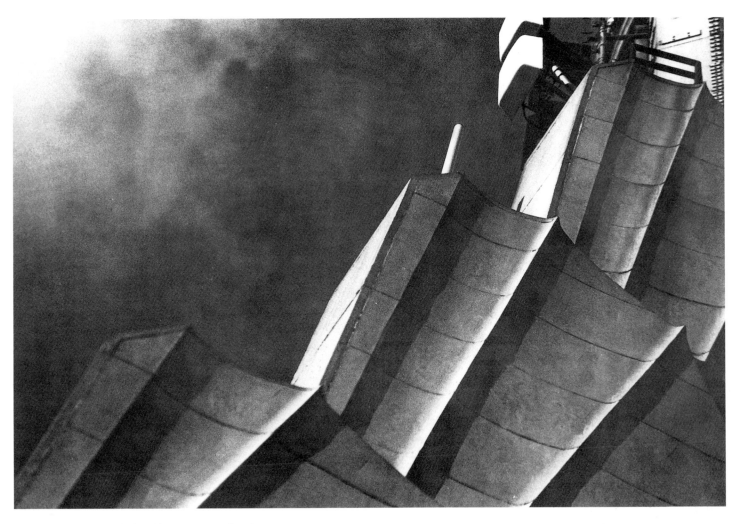

New York, Empire State Building, exterior-detail.

Rockefeller, who had already signed a lease for the property, decided to proceed on his own.

The change in economic circumstances meant that the original cultural emphasis of the project would be subordinated to a commercial purpose. The enterprise was given a boost, and a new direction, when the powerful Radio Corporation of America (RCA) agreed to become the principal tenant of the proposed complex. What had been conceived as a cultural center for the elite was transformed into an entertainment center for the masses, and its name was to be Radio City.

The difficult financial circumstances also led to a decision to emphasize quality. The new commercial space would have to be the best available, in order to attract as many tenants as possible. The emphasis on quality, and the complexity of the undertaking, led Rockefeller to engage a team of architects, including the firm of Reinhard and Hofmeister, and the well-known architects Harvey Wiley Corbett (of Corbett Harrison and MacMurray), and Raymond Hood (of Hood and Fouilhoux), all working under the umbrella of "Associated Architects."

Out of a constant tension between practical exigencies and aesthetic vision (represented primarily by Hood), there emerged a three-dimensional plan, with interrelated skyscrapers, open spaces, and an underground concourse. It could be seen as an American version, with an added emphasis on the vertical dimension, of European urban design, even going back centuries to the Roman Forum. Notwithstanding the scope of the undertaking, and the inevitable difficulties of design by committee, there is a unity and coherence in the buildings and the decorations, both inside and out, exemplified in the various lobbies, corridors, elevators, shops, ventilators, frescoes, and so on. The visitor is led effortlessly, as if by an invisible guide, through various homogeneous levels, where the play of converging lines and the allure of harmonious spaces beckon to pause and admire.[33]

Art was an integral part of the project, and Rockefeller allocated a substantial sum just for that purpose. The art program was intended to have an edifying purpose, and its theme was "New Frontiers and the March of Civilization." Here, more than elsewhere, the viewer is struck by the symbolic use of ornament, in the form of murals, statues, carvings, plaques, many telling stories. At the entrance to the International Building is Lee Lawrie's statue of Atlas carrying a schematic globe, to represent

cooperation and peace among all peoples. The Lower Plaza is dominated in turn by the bright, gilded shape of Prometheus by Paul Manship. And over the entrance to the RCA (now GE) Building is the figure of Genius holding a compass, a construction in limestone and colored glass also by Lawrie, which was inspired by "The Ancient of Days," one of Blake's illustrations showing the creator as architect, his hand leaning on a huge compass. Lawrie's transposition of the Blakean image was an aptly chosen icon to underscore the general theme of the "March of Civilization."

The words incised below the figure have a biblical association: "Wisdom and knowledge shall be the stability of thy times" is a direct citation from the Book of Isaiah (33:6). Placed as they are in a civic context, the words and the image of Genius negate any religious connotations and emphasize instead the strength and power of the "brave new world." Meanwhile, the colored panels on either side of Genius symbolize Light and Sound, calling attention to the function of the building and its associated enterprises, namely the business of radio and cinema, and now also of television. The interior murals take up the theme of "New Frontiers" in their representation of "American Progress" and of the history of transportation from the wagon trains of the pioneers to the early days of flying. As Walter Karp puts it, "The combination of commerce and idealism seemed almost Victorian, but the art produced was pure 1930s style."[34]

The formative influence on the Center can be traced to the Ecole des Beaux Arts, where many American architects were trained, but there are also some of the most interesting examples of modern and Deco in the United States. The Center is composed of 19 buildings. Those of the original plan were built between 1931 and 1939, with later additions beginning in the 50s. To this day, Rockefeller Center continues to grow and to be renewed, with the addition of residences, commercial centers, and popular attractions such as the Fashion Café, owned by four world-famous super models.

The RCA (now General Electric) Building, the central structure of the complex, can be accessed from various buildings, small squares, private and public vestibules, intersecting axes, and open spaces at different levels, such as Rockefeller Plaza and the Lower Plaza, which, via the Channel Gardens with their flower beds that change colors with the seasons, are joined to the most elegant

part of Fifth Avenue. Besides the ground level gardens, the architect Raymond Hood who, until his death in 1934 was the inspirational leader of the team of architects and designers, introduced the roof garden — an idea which he took from luxury apartments and hotels — in order to make the view of the city more pleasant for the people working at the Center by offering them a flowery panorama. It is that which even today fascinates when we go up to the famous Rainbow Room, a center of the city's night life.

We conclude our tour of this vibrant heart of the city with a visit to one of its most significant sites, where business and entertainment are joined, namely Radio City Music Hall. This theater — together with a second, the Center Theater, which was demolished in 1954 — is linked to the name of the impresario Samuel Lionel Rothafel, better known as Roxy, a legendary showman who had perfected the art of combining vaudeville with the new muse, cinema. In 1931, Roxy was hired to manage the two theaters at Rockefeller Center. The interior design of the Music Hall was entrusted to Donald Deskey, one of the leading exponents of "contemporary design," which we now know as Art Deco. When Radio City Music Hall opened in 1932, it was the world's largest indoor theater, with a capacity of close to 6000. The trend-setting design of the auditorium — a huge movable stage below sweeping concentric arches opening out like a shell — established a form which would be widely imitated. The unified Deco style — which extended even to the restrooms — is still much admired. And everything was done on an unprecedented scale, from the auditorium, which combined European and American ideas with the most modern technology, to the creation of that now famous chorus line of legendary precision, the Rockettes — originally the Roxyettes. Even today the visitor is struck by the scale of the Grand Foyer with its immense mural by Ezra Winter, covering an entire wall and dominating the stairway, and representing the myth of the fountain of eternal youth.

Moving now to Park Avenue, we come to a building which has certainly seen its share of millionaires, the Waldorf-Astoria Hotel, the 'Mega-House,' new model of life and habitation. The hotel moved to its present site from Fifth Avenue after intense infighting among the various branches of the Astor family, and after the previous location — where the Empire State Building is now

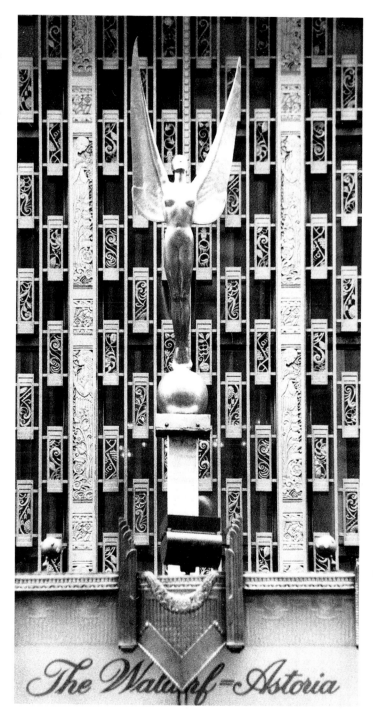

New York, The Waldorf-Astoria, 301 Park Ave. (Schultze and Weaver, 1930-31), front entrance-detail.

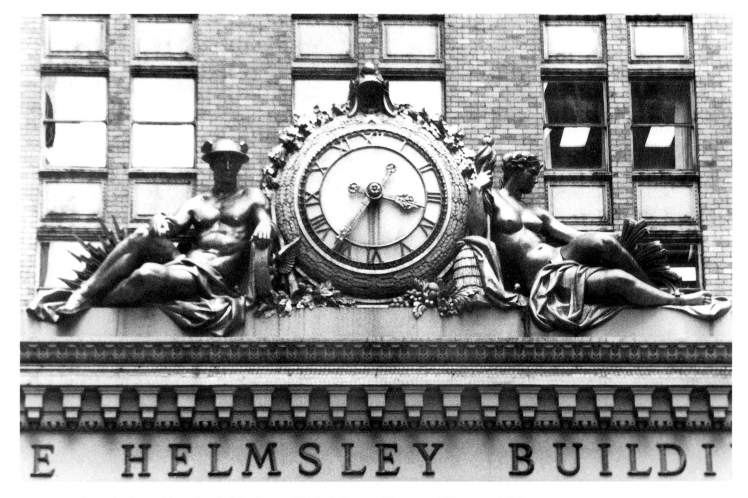

New York, The Helmsley Building, detail of the front at 230 Park Avenue (Warren and Wetmore, 1929).

located — had been abandoned due to increased noise and congestion. This splendid building ennobles the entire street and gives it that touch of elegance and exclusiveness which has always attracted high society, the aristocracy of title and of money, from all over the world. Still today it is patronized by famous names from the world of art and politics.

Designed by Schultze & Weaver and completed in 1931, the front of the building consists of a massive slab rising on a steel structure and terminating in twin towers, each topped by a turret heavily decorated with the friezes and gilt typical of Deco ornamentation. The main entrance sets a tone of refined simplicity. Inside, the lobby is

particularly sumptuous, a showpiece where elegance is the predominant trait. In the center of the reception hall stands a clock of exceptionally fine workmanship. Flocks of attendants see to it that proper behavior is maintained in consideration of the hotel's many illustrious guests.

Park Avenue, itself home to many wealthy families which sought refuge from the noise and congested traffic of Fifth Avenue, is perhaps New York's most scenographic street, with Warren & Wetmore's Helmsley Building (1929; originally the New York Central Building) serving as a backdrop.

With its vaguely rococo gilded cupola, it stands against the geometric silhouette of the Pan Am Building. This

ensemble of structures dominates Grand Central Station, which opens onto 42nd Street, almost opposite the Chanin Building.

In the same neighborhood, on Lexington Avenue at the corner of 51st Street, is the General Electric Building, a project realized in 1930-31 by the firm of Cross and Cross. This sandstone tower with its colored roofing tiles — materials which it shares with the nearby St. Bartholomew Church — is richly decorated with copper spires and terra cotta reliefs. Also on Lexington Avenue, next to one of the side entrances of Grand Central Station, the facade of the Graybar Building, designed by Sloan and Robertson in 1927, exhibits colorful figures of Assyro-Babylonian inspiration .

The tour of New York Deco does not, of course, end here. On practically every corner, and not only in Manhattan, there are structures of great interest which were built during the period from the late twenties to the late thirties. But since it would be impossible to mention them all, we shall finish by pointing out just a few of the other masterpieces of New York Deco, and leave the rest to the joy of discovery and exploration.

The first significant Deco skyscraper in New York, designed by Ralph Walker for the firm McKenzie, Voorhees, & Gmelin, was the Barclay-Vesey Building at 140 West Street, completed in 1926, and chosen as the frontispiece illustration for the English edition of Le Corbusier's programmatic *Towards a New Architecture*. Influenced by the Paris Exposition, this massive building, with its receding levels, would in its turn influence later skyscrapers with its use of stylized natural elements as decoration, thus adding a human dimension to the mechanical functionality of the structure.

The Paramount Theater Building at 1501 Broadway, designed by the Chicago firm of Rapp & Rapp and completed in 1926, starts from a massive block which is topped with a Deco flourish: a stepped pyramid supporting a gigantic clock and culminating in a glass ball at the point. Towards the East River, at 3 Mitchell Place — an extension of 49th Street — on the corner of First Avenue, stands the slender and elegant Panhellenic (now Beekman) Tower. An effective restoration has brought out the vertical elements of the brick, terra cotta and granite surface, which rise unbroken and, in the words of the architect John Mead Howells himself, "end against the sky" in the manner of "a growth of pine trees or a palisade

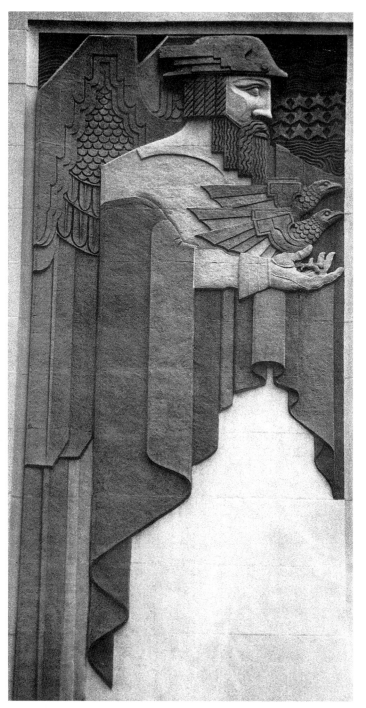

69

New York, Graybar Building, 420 Lexington Ave. (Sloan and Robertson, 1926-27), exterior-detail.

or cliff." [35] Inside, the small but elegant lobby is a perfect example of scenographic Deco.

Also due to the work of the often mentioned Raymond Hood, here for the firm of Hood, Godley & Fouilhoux, is the McGraw-Hill Building (now GHI Building) of 1931, whose severe functionalist lines are brightened by the banding of the blue-green terra cotta spandrels, and the colorful treatment of the entrance at 330 West 42nd Street. Because of its links with the futurist and international style, it was included in the now famous book by Philip Johnson and Henry-Russell Hitchcock, *The International Style*, published in 1932.

At the corner of Madison Avenue and 57th Street, the Fuller Building, built by Walker & Gillette in 1929, is a tall, shapely tower where the decorative use of black granite and light gray brick creates a striking effect, outside as well as inside. Of particular note are Elie Nadelman's sculptures, perched above the three-story entrance portal. Two muscular, larger-than-life male figures are separated by an octagonal Deco clock, and set against a flat, symmetrical backdrop suggesting a skyline of stylized skyscrapers. The presence of Egyptian and Roman motifs is noticeable throughout the edifice, while the building's crown is embellished with motifs of pre-Columbian inspiration. A small anecdote: the Fuller Building was one of the skyscrapers represented in the legendary costume parade on the occasion of the Beaux Arts Ball held in 1931, where many of the great architects participated wearing costumes in the shape of their respective buildings. A few years later, Busby Berkeley choreographed dancing skyscrapers to stunning effect in one of his most famous musicals which was called, not by chance, *42nd Street*.

Still on Madison, at the corner of 34th Street, we find the entrance of another building echoing the Paris Exposition, the Cheney Brothers Building, now the Belmont Madison Building. The bronze doors and the other metallic decorations, dating back to 1925, are the work of Edgar Brandt, a true master of wrought iron work, and provide a splendid example of the motif of the "frozen fountain" in gilded bronze. Other noteworthy structures include: the Chelsea Hotel, on 23rd St., and many office buildings on Fifth Ave., such as 500 Fifth Avenue and Lefcourt National Bldg., 521 Fifth Ave.; the Daily News Building, back on 42nd Street, also designed by Hood with sculptures by Chambellan; Bloomingdale's Department Store on Lexington Avenue, with one wing in a vaguely Mayan style, built by Starrett & Van Vleck in 1930; the famous Macy's, forever linked to the story of American Deco; and exclusive Tiffany's on Fifth Avenue, a design of later vintage (1939-40), in which the Deco influence — including the clock on the shoulders of Atlas above the main door — has been tempered by austerity. The Empire Diner, on 22nd Street and 10th Avenue, is a classic of the genre, and the Rialto Theater (later Cineplex Odeon Warner), one of the first movie houses on Times Square, is notable for its Deco facade in blue Vitrolite. [36]

Special mention goes to two great architects whose work helped give an international tone to American Deco without, however, ignoring local characteristics. We are thinking of the Austrian-born Joseph Urban and the American-born, European-trained Ely Jacques Kahn. Urban's projects included the New School (1930), on 12th Street, with an auditorium of beautiful proportions which is just as noteworthy as the one by Associated Architects for Radio City Music Hall or as Lloyd Wright's shell design for the Hollywood Bowl in Los Angeles. Other influential designs by Urban include the International (now Hearst) Magazine Building, decorated with monumental columns and statues of vaguely Viennese inspiration, the Central Park Casino, with its handsome murals, and the Ziegfeld Theater, both now destroyed, and the unrealized designs for the Reinhardt Theater and the Metropolitan Opera House. The latter influenced the design of the Radio City Music Hall, which ultimately replaced it. Many of Urban's drawings and projects, including photographs of buildings now demolished, can be seen in Columbia University's rich collection.

To Ely Jacques Kahn's vivacious imagination are due some singular constructions, like the Two Park Avenue Building of 1927, where the use of color is particularly original. In 1931, Kahn wrote: "The dream of a colored city, buildings in harmonious tones making great masses of beautiful pattern, may be less of a vision if the enterprising city developer suspects the result. There is evident economy of effort in the application of color in lieu of carved decoration that cannot be seen and the novelty of a structure that can be distinguished from its nondescript neighbors has practical value that must appeal without question to the designer and his public." [37] The Film Center Building on 9th Avenue between 44th and 45th

New York, Belmont-Madison Building, 181-183 Madison Ave. at 34th St. (Howard Greenley, metalwork Edgar Brandt, 1925).

72

New York, Chelsea Hotel, 222 W. 23rd St., detail of the balcony.

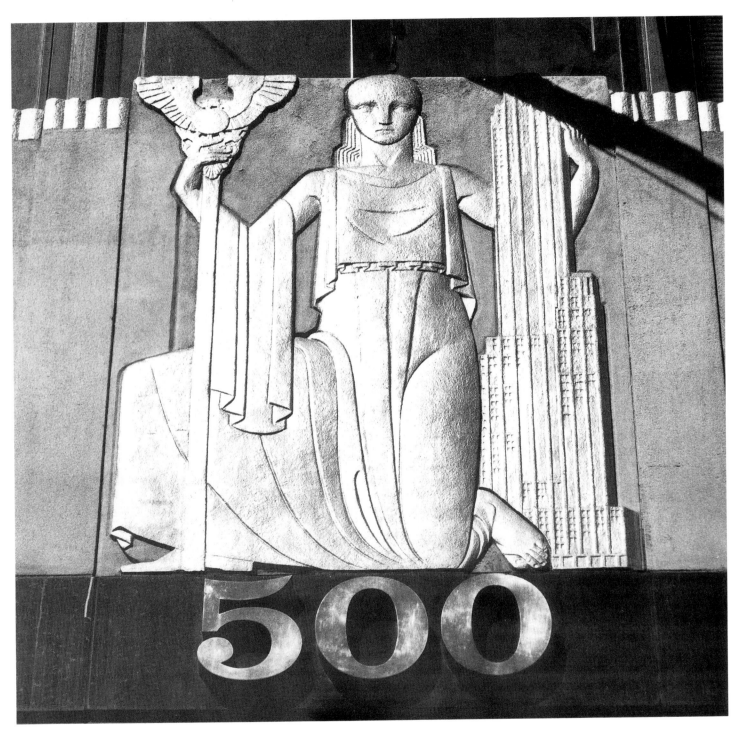

New York, 500 5th Avenue, main entrance-detail.

New York, Lefcourt National Building, 521 5th Ave., detail, the clock over the main entrance.

Streets dates back to 1928.

The lobby of this building is, in keeping with its architect's convictions, a triumph of colors, underscored by the clever use of geometric and ziggurat decorations which blend the Mayan style with the constructivism of the Viennese Secession.

The details of such common elements as mail boxes and elevators make of this building an undisputed and original Deco masterpiece.

PHOENIX: ARIZONA BILTMORE HOTEL

"It's virtually impossible to walk the length of the lobby without sensing the Biltmore's timeless power. It is this magical, undefinable sense of space, rather than any more easily identifiable 'things', that constitutes its enduring legacy."
Vernon D. Swaback.

Of all the hotels that we have visited, even the most beautiful and the most refined, the hotel par excellence where the sophisticated traveler can take refuge in his/her dreams and desires, is undoubtedly the Arizona Biltmore, which has been called "the jewel of the desert." In fact , the story, which reads like a fable, begins in the desert outside Phoenix in 1924. Two brothers, enterprising contractors, dreamed of transforming this barren, arid land into a grand tourist area, creating a golden oasis, worthy of the most distinguished clientele in the world, where once there was only an anonymous little frontier town. On February 23, 1929 the Arizona Biltmore opened its doors, welcoming six hundred invited guests with a sumptuous dinner party.

Albert Chase McArthur, the older of the two brothers, and himself an architect, had asked for the help and advice of Frank Lloyd Wright, having worked in Wright's office in the Chicago suburb of Oak Park. Although he initially accepted a challenge so perfectly suited to his style, Wright did not want to be officially associated with the project. "I was to remain incognito," he said.[38] But his teaching and his touch are perfectly recognizable in the hotel's various buildings, which bear the unmistakable signature of Frank Lloyd Wright.[39]

McArthur, the owner and architect of record, emphasized Wright's style throughout the whole complex and, in order to give it an even more authentic feel, he placed in front of the entrance some of the stylized female statuettes called "Sprites," which were designed by Wright and sculpted by Alfonso Iannelli in 1914 for the Midway Gardens in Chicago, and which were saved from destruction when the Gardens were demolished in 1929. These slender little columns blend perfectly with the building and the surrounding landscape, acting as mystical and mysterious protectors of the site.

In keeping with Wright's teaching, McArthur preferred materials which respect the spirit of the place. Accordingly, the concrete blocks used in the construction — which were manufactured on site using Wright's "textile block" system — are decorated with Mayan-style motifs by the sculptor Emry Kopta, and have the warm color of the Arizona rock.

Over the years, the structure has experienced various ups and downs which have mirrored the fortunes of the hotel, but it has now been returned to its pristine splendor, thanks to careful restoration work and some additions which blend perfectly with the original buildings. The entrepreneur and chewing-gum magnate William Wrigley, Jr., whose holdings also include Catalina Island, was one of the first investors and, until the seventies, the only stockholder.

Appearing from without like a Norman fortress with pre-Columbian influences, the entire complex demonstrates a knowledgeable use of volumes and ornament, so that even the surrounding palm trees, like tall, slender, natural columns, become an extension of the architecture. In keeping with the principle of constant exchange between nature and art, the stylized character of these natural palms accentuates nature's stylization and, at the same time, naturalizes the artificiality of the structure. On the inside, representations of palm trees decorate the walls and create an understated and recurring motif. In fact, the designer of the interiors, architect John Cottrell, maintained that since the architecture was so strong, there was no need for much decoration on the inside, which is indeed an example of good taste and sensitive understatement. The various conference and reception rooms have emblematic names, like the Aztec Room or the Gold Room. The ceiling of the splendid lobby is decorated with leaves of gilded copper, a material which comes from Arizona mines, while a tapestry with native American stories reminds visitors of the history of the place.

Crowds of celebrities have stayed at the Arizona Biltmore, from Clark Gable to Joan Crawford, from Fred Astaire to Irving Berlin, who is supposed to have composed there his famous "White Christmas." More recent guests include Marilyn Monroe, who made the spectacular swimming pool, "Paradise Pool," famous by dipping in its waters, and Steven Spielberg. And among those who have spent their

romantic honeymoon at the Biltmore is the historic couple of cinema and politics, Ronald Reagan and Nancy Davis.

Enclosing the adjacent cottages and the splendid gardens which have tamed the desert around the hotel, low cement walls with Mayan decorations pick up the guiding motifs of the principle building, thus making the whole sumptuously homogeneous and coherent. In the hills of Los Angeles we will visit some houses designed by Wright in exactly this style.

DENVER AND BOULDER, COLORADO

"...the art of building movie palaces developed into 'one of the richest and most imaginative and transitory schools of architecture since the discovery of the keystone.'"

Jerome Charyn

From Arizona and the splendors of the Biltmore, we go to the movies in Colorado. For us, cinema has a mysterious fascination; it is a surrogate reality that knows no bounds and that until recently could be found everywhere in America, from the biggest city to the smallest town. Movie houses were often the only places where a certain luxury was accessible to all levels of the population and, in keeping with their aim of "teaching new ways to dream"(as Norma Desmond sings in the musical *Sunset Boulevard* [1996] based on the movie of the same name), they were built in the most opulent styles, incorporating stylistic elements of the most imaginative exoticism. People entering a movie house entered — as Jerome Charyn would say — the obscure caves of their deepest desires and found a golden garden. "They walked into movie palaces that could have been conceived by Kubla Kahn and searched for some emerald city on the screen, like that Venice where Ginger and Fred danced in *Top Hat*, with seaplanes sitting in a glass lagoon" (Charyn, 108).

Let us then make a small detour in our journey towards the West Coast, because in Colorado there are some Deco buildings which merit our attention, and in particular, two movie palaces.

In Denver, between 1st Street and Broadway, we find the Mayan Theater. It opened in 1930 with a spectacular all-night celebration in which Native Americans in costume drummed and danced on the roof. Designed by the Architect Montana S. Fallis, the lines of the building are made up of a combination of traditional and Mayan forms. The central section of the facade is topped by a triangular, vaguely Romanesque pediment. But Mesoamerican models seem to have inspired other parts of the structure, including the upper part of the facade, whose receding volumes suggest a Mayan pyramid, and the pointed arches above the marquee, which evoke the Mayan corbeled arch. The facade is decorated with colorful terra cotta ornamentation, the work of Julius P. Ambusch of the Denver Northwest Terra Cotta Company, including a representation of a Mayan chief and several zigzag friezes. Similar decorative motifs are repeated inside, in the small

and elegant foyer, and in the auditorium, where stylized water lilies and splendid masks, including that of the Jaguar God, decorate the proscenium arch. The entire structure has been designated a Denver Landmark.

At 1631 Glenarm Place, there is another theater dating back to the same period — the Paramount — and next to it, a popular café of the same name which blends the Deco style, typical of cafés of the thirties, with the more dynamic and futuristic look of the diners of the forties. From the outside, the theater presents a low profile: its facade is covered with the shining white majolica tiles which were in vogue in those years, and its entrance is emphasized, in the manner favored by its architect, Temple H. Buell, by neo-Gothic pinnacles. But once inside, the visitor is surprised with the grandeur, the sumptuousness, and the variety of the decorative elements. As observed by Noel and Norgren in their book *Denver: The City Beautiful and its Architects, 1893-1941*: "The Paramount Theater is the only great movie palace of those years which has remained unchanged in the Denver city center" (132). This by now rare example of Art Deco has a capacity of 2100 seats arranged in a "cavernous" space enlivened by gilded stucco moldings, geometric motifs, and orientalizing figures. Along the walls, between the moldings, are painted silk panels representing characters from the Commedia dell'Arte, while on the stage sit the twin consoles of the Mighty Wurlitzer organ — the only one of its kind outside of Radio City Music Hall in New York — an instrument designed for use in theaters and movie palaces, and capable of producing an astounding range of sounds.

During those years, as often mentioned, much attention was given to spaces dedicated to public amusement and entertainment, like public parks, fairs, party pavilions and casinos. This was the case in Denver, too, and although most of the structures from the period no longer exist, Lakeside Amusement Park's Auto Skooter is still housed in a Streamline Moderne building which dates from the 30's. A short distance from the recently restored railroad station, which now stands out like a Western movie set in

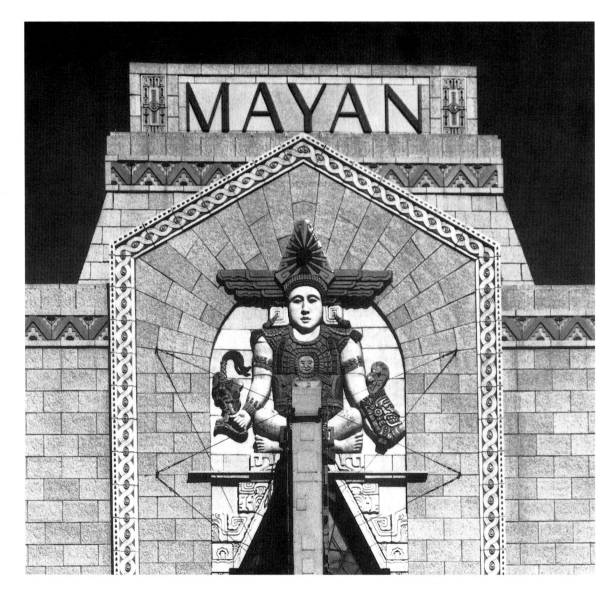

Denver, Mayan Theatre, 110 Broadway (Montana S. Fallis, 1930).

the newly fashionable area known as Lo-Do (lower downtown), is another Denver attraction — the Cruise Room Bar of the Oxford Hotel — which has remained virtually intact since it opened in the mid-thirties. Patterned after a similar facility on the Queen Mary, the room is long and narrow, with a stainless-steel trimmed, black Vitrolite bar going down one side, and darkly upholstered booths lined up on the other. Along the walls, illuminated by neon lights on the sides and overhead, are panels painted in various shades of pink, each representing a different part of the world, from Russia to France, and from the Far East to America, the latter

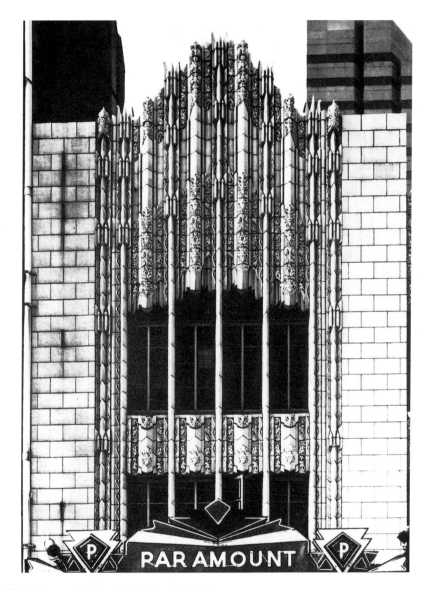

Denver, Paramount Theatre, 1631 Glenarm Pl. (Temple H. Buell, 1930).

identified by the presence of a Native American in a feather headdress, local trees and birds, and a train, symbol of the mechanized conquest of the West.

In the hotel itself (built in 1891 by Frank Edbrooke, with a later annex by Montana Fallis), there are still a few rooms in perfect Deco style, with the original furniture, clocks, and mirrors. They are lovingly kept and shown to visitors with justified pride.

Downtown Denver has other interesting Deco buildings, including The Mountain States Telephone and Telegraph Building (now occupied by the current regional incarnation of the telephone company, US West) at 14th

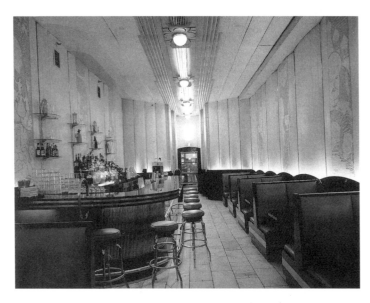

Denver, Cruise Room Bar, Oxford Hotel, 1600 17th St. at Wazee.

and Curtis. Designed by William Norman Bowman and completed in 1929, it is a large building with a stepped back structure in Deco-Gothic style, adorned with pinnacles and heraldic emblems. Outside both entrances to the building, as well as in the main lobby, are murals by Allen True which commemorate the development of modern communications in Colorado. When announcing the building's construction, the original Mountain States Telephone Company promised that it would be a "Temple of telephonic speech to rise above the skyline like a beautiful castle."

We turn now to some private homes in Denver, built in an exclusive area of the city with large yards and well-established gardens. Towards the mid-thirties, thanks first of all to some talented architects, like Casper F. Hegner, Lester L. Jones, Burnham Hoyt, and Victor Hornbein, Denver residential architecture lived a splendid season of the International Style, truly "going modern," as suggested by the title of Don D. Etter's excellent book. These elegant private homes, concentrated in the area between Cherry Creek and Denver University, are characterized by the use of brick, glass, and white and pink stucco in lively geometric configurations, often incorporating a streamline curve into an otherwise rectilinear structure composed of different-sized blocks.

To all but those who know Denver well, this neighborhood, which is quite secluded both from the imposing skyscrapers of downtown Denver — familiar to all viewers of "Dynasty" — and from more recently developed shopping centers, is a secret, yet it contains numerous excellent examples of private homes built in the style of American Modernism which blends the essential functionality of the home with intelligent landscape architecture.

At about 30 miles from Denver, in the University town of Boulder, another movie house, the Boulder Theater, has a triangular marquee supporting the name of the theater in large letters, and itself supported by a kind of platform with streamlined corners, the whole outlined in various colors of neon. The upper part of the facade rises to a stepped parapet and is decorated with three colorful terra cotta panels which are dominated by the fan motif. The theater, which was built in 1935, has changed use several times in an effort to save it from demolition. It is now protected as a designated City of Boulder Landmark.

Across the street from the theater is another Deco structure. The old Court House, now home to various county offices, was designed by Glenn H. Huntington in 1933. It consists of a massive central tower with multiple setbacks tying it to two similar, flanking wings. A new fountain, built in front of the Court House with the support of Lions International, echoes the architectural lines of the building. Until recently, Boulder also had an interesting example of Deco revival architecture: namely, a nineteen sixties version of the classic diner. Unfortunately the L.A. (Last American) Diner was recently demolished. The facade consisted of a wide band of aluminum or stainless steel. In the center there was a clock surmounted by a miniature tympanum and by two slender antennas. The interior was a medley of steel and plastic. Between the tables, each with its own juke box, waitresses on roller skates served cokes and chocolate shakes. This was one of the possible forms of the diner: a one story building, quite unpretentious, just right for serving quick, inexpensive snacks, and typically found in the Northeast. The other model, of the Streamline Modern type, was a long low structure, part railroad car, part mobile home, an example of which might be the Fog City diner, near the embarcadero in San Francisco, and the stainless steel 11th St. Diner in Miami Beach.

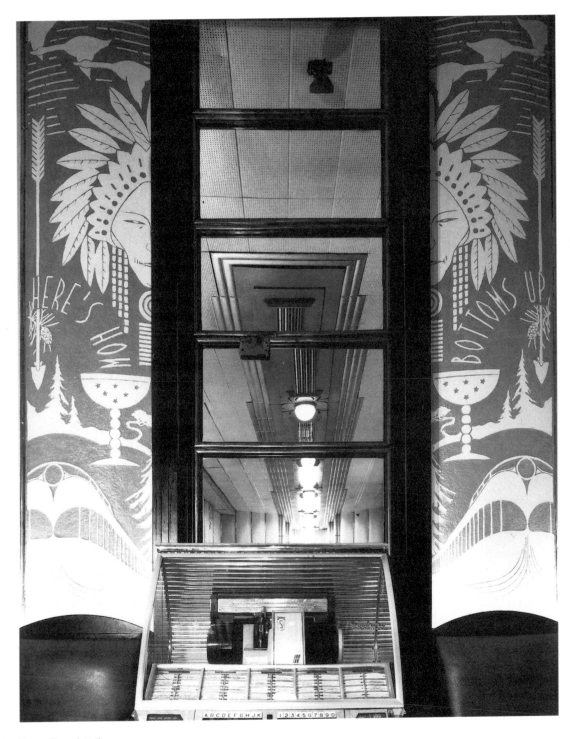

Denver, Cruise Room Bar, detail.

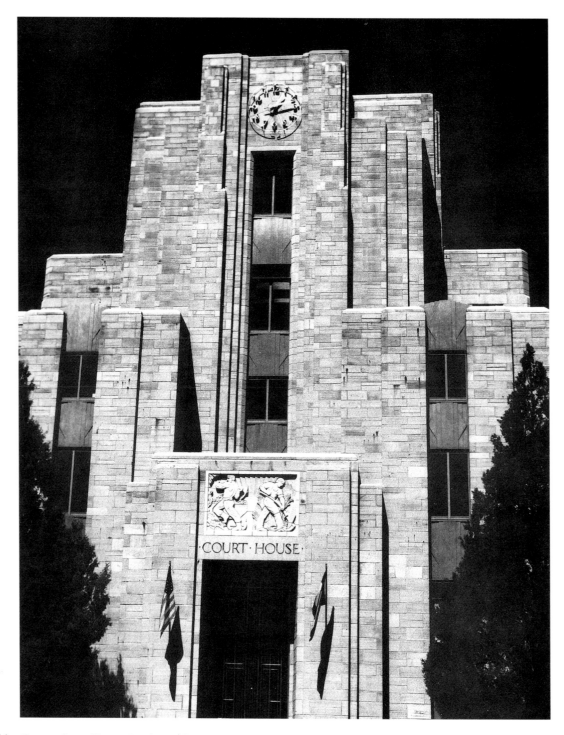

Boulder, Boulder County Court House, Pearl at 14th St. (G. H. Huntington, 1933).

SEATTLE

"The white man will never be alone. Let him be just and deal kindly with my people, for the dead are not powerless."

Chief Seattle, 1885

On the Pacific coast, north of California and Oregon in Washington State, lies the city of Seattle, widely regarded as one of the most livable cities in the United States, both for its natural beauty and ethnic variety.

Founded in the middle of the 19th century, Seattle has witnessed the creative enterprise of building contractors and architects in the various phases of its growth and urban development. Nature has favored it with a protected bay and many islands, and surrounded it with green hills and the backdrop of the snow-capped mountains of the North Cascades. This young city has tried to find an equilibrium between the past and the future: Boeing was born here and it is the home of Microsoft. The various styles of American architecture are represented by examples of notable interest.

With regard to Deco, Seattle offers a number of worthy buildings. In part, this is due to the flair and the dedication of an outstanding architect, Carl F. Gould, who came to Seattle from New York in 1908, and contributed in a determined fashion to the development of the modern city.[40] He too, like so many other architects educated at the Ecole des Beaux-Arts, was in search of a true American style. He blended native traditions with the eclecticism that was dominant at the time, without ignoring the drive towards modernism, thus producing many important and personal versions of Deco, especially after he began his collaboration with Charles Herbert Bebb in 1914. In the same year, Gould was appointed to head the newly formed Department of Architecture at the University of Washington, where he also began to teach, and in addition, the firm of Bebb & Gould was awarded the commission to prepare a new master plan for the campus. Gould's work on both building up the architecture department and revising the campus plan received a considerable impetus in 1915, when the energetic Henry Suzzallo became president of the University of Washington. Suzzallo was a man of modern and decisive ideas, and supported Gould's projects with great generosity and vision.

Among the architects of the time, Gould stands out, certainly in terms of his versatility and inexhaustible imagination. His project for the famous *Chicago Tribune* competition, though it did not win, received a special mention. And his contribution was essential to the urban development of Seattle and of the University of Washington. Supported, as noted, by the enterprising President Suzzallo, he visualized a University adapted to the spirit of Seattle, that is to say, a University for the city and a city for the University. Gould applied the rules of the "City Beautiful" movement with a personal flair. The other principle which inspired him was that a city must harmonize in beauty with the beauty of its natural surroundings. He used to say that "Beauty is the very soul of our profession," and his buildings certainly exemplify those rules.

Of the twenty-eight buildings which Gould designed on the beautifully landscaped University of Washington campus, the principal building is the Central Library (now Suzzallo Library), of 1922-26, with a later addition, also by Gould in 1933-34 — an imposing structure, rich in pinnacles, arches, rose windows, chevrons, and moldings of gothic inspiration, but revisited in the spirit of Deco. Presenting itself as a cathedral of learning, the library's facade is adorned with eighteen statues (by the sculptor Allan Clark) of great contributors to "learning and culture." For the vast and carefully proportioned reading room, Gould designed — as was the practice of many of his peers, including Frank Lloyd Wright — the furnishings and fixtures, including chandeliers in a style which might be called gothic-oriental Deco.

The Deco influence is more apparent in the later Horace C. Henry Art Gallery (1926), which might be described as Tudor Deco. The low structure has the form of a simple, rectangular box. Decoration is provided by the use of light-colored stone on the cornice and at the base, and to frame the main portal and the several decorative niches, which, together with finely carved bands and small allegorical statues placed high at each of the four corners of the building, create an embroidery effect on the red brick surface.

83

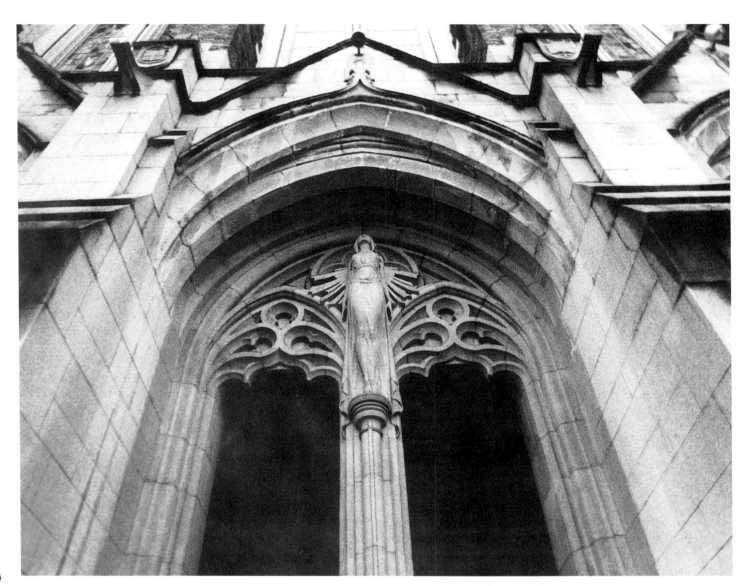

Seattle, Suzzallo Library, University of Washington (Bebb and Gould, 1922-26, 1933-34; sculpt. A. Clark, 1924), detail over the portal.

Our next stop is Volunteer Park to see what is surely the most important Deco work of Bebb & Gould, namely, the Seattle Art Museum (now the Seattle Asian Art Museum), built in 1931-33 when Gould was already one of the most successful architects in Seattle. The project met with the approval of a wealthy philanthropist, geologist and collector, Richard Fuller, who donated precious works of art to the Museum. The building is a splendid edifice in which Gould blends, in a highly personal way, the best achievements of Art Deco with the clean lines of the Moderne Style. The central section of the main façade has the form of a convex block, reminiscent of a mausoleum, which is divided into three sections, each containing a door and surmounted by a large window, the whole decorated with metal grillwork of elegant workmanship. On either side of this central block, the two wings exhibit

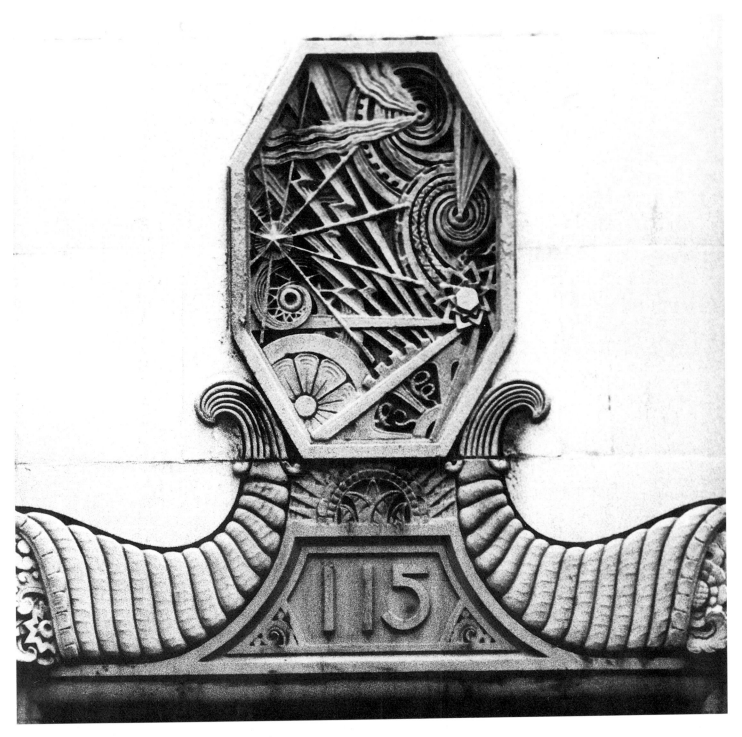

Seattle, Jackson Antiques, 115 South Jackson, detail.

an ornamentation of delicate geometric patterns which add variety to the surfaces and underscore the rhythm of the entire structure. Fuller himself, in agreement with Gould, wanted a building without precedent. He said, "The attempt to achieve permanent beauty principally by refinement of shape and proportion, with only a restrained use of accessory ornamentation, has greatly emphasized the necessity of perfect workmanship" (Booth and Wilson, 157). One of the few decorative elements, but one of great effect, is two kneeling camels, one at each side of the door, which seem to be watching over the treasures within.

Inside, the foyer offers the visitor a harmonious composition of volumes emphasized by the scansion of horizontal steel bands which give the space an elegant tone recalling the International Style. All the finishing touches are in perfect harmony, from the light fixtures to the radiator grills.

Between Twelfth and Fourteenth Avenue South rises the massive outline of the U.S. Marine Hospital (now Pacific Medical Center) built by Bebb & Gould between 1930 and 1932. The Seattle hospital is composed of a tower-like central block and two sets of flanking wings. As Gould himself described it: "I look up[on] our design as a well proportioned package or a series of parallelopipeds bound together as if by sturdy rope carried in two directions & thereby erect a sense of unity" (Booth and Wilson, 149). The "ropes" on the three central blocks, or parallelopipeds, are unbroken vertical piers. Horizontally, the window spandrels, although not physically continuous, are unified by common decorative elements. In contrast, on the outermost, and lowest, wings, it is the horizontal line of the sprandrels which is continuous, with the vertical "ropes" being synthesized optically through the use of decorative brick. The overall effect is, as Gould proclaimed, to create a sense of well-proportioned unity.

Another interesting aspect of Gould's work falls into the category of what might be called "Commercial Modernism." Living in the age of the triumph of the automobile, the problems associated with this new form of transportation became one of the architect's primary concerns as an urban planner and designer. He proved himself to be a true modernist who could create structures suited to new ways and new technologies. In fact, he designed spacious garages for many important and affluent Seattle families, as well as automobile showrooms with wide windows and exterior decorations in colorful terra cotta.

Of course, Bebb & Gould were not the only architects in Seattle. Traveling through the downtown streets between the Pike Street Market and Pioneer Square, various other fine examples of Deco architecture merit our attention, such as the attractive Jackson Antiques store. At 301 Pike Street there is one of the few remaining examples of an original Woolworth store (now Ross Department Store), built in 1938 by Harold B. Hamhill. It is built on a corner, where it is anchored by a central tower whose chamfered side bore the name of the store in huge letters. The exterior is sheathed in beige terra cotta, with a wide frieze of a darker shade just above the street level display windows.

The United Shopping Tower (1928-31; now Olympic Tower) designed by Henry W. Bittman, rises up between Pine and 3rd Avenue. The classic verticals, the sheen of the white terra cotta sheathing, the ornamental bands of delicate chevrons, flowers, fans, and other stylized elements, all have an irresistible appeal for aficionados of Deco. Dating the same years is a work of John Graham, Sr., (who also designed the city's signature Bon Marché department store, known affectionately to locals as "the Bon"), namely, the Exchange Building on 2nd Avenue, a more massive high rise with symmetrical setbacks near the top, and floral decoration of French influence. The lobby, in somber black marble, has an imposing gilded ceiling with inlaid geometric patterns.

On First Avenue we find the Colman Building, by the architect Arthur Loveless, with its extraordinary bronze panels where the sculptor Dudley Pratt in 1930 depicted local industries, notably the aircraft industry, which has become synonymous with Seattle, as well as the lumber industry, thus creating an ideal bridge between the pioneer past and the jet-age future. Also on First Avenue, at the corner with Marion, is the Federal Office Building (1931-33), designed by James A. Wetmore, and displaying an unusual variety of materials, including red brick, light-colored concrete, glass, granite and terra cotta. Still a property of the federal government, the building proudly exhibits the traditional eagle above the main entrance.

On 3rd Avenue, the Northern Life Tower (now Seattle Tower), built in 1928 by the firm of Albertson, Wilson and Richardson, is widely regarded as the most beautiful Deco

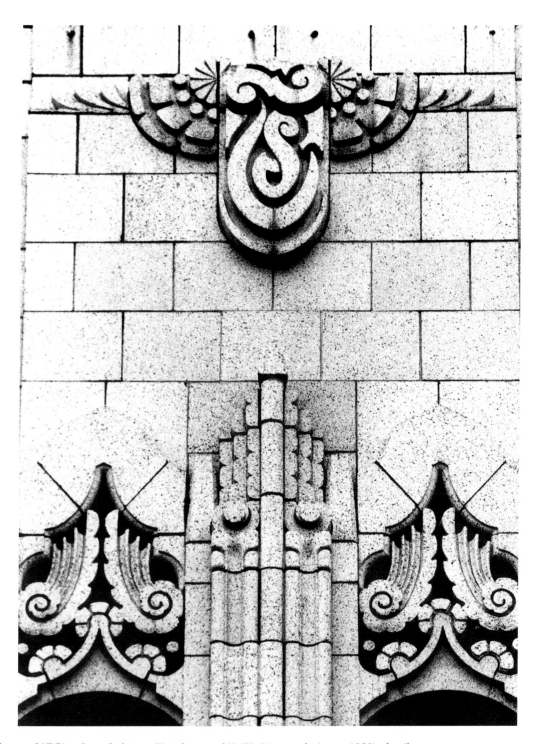

Seattle, Olympic Tower, 217 Pine St. at 3rd Ave. (H. Adams and H. W. Bittman designer, 1929), detail.

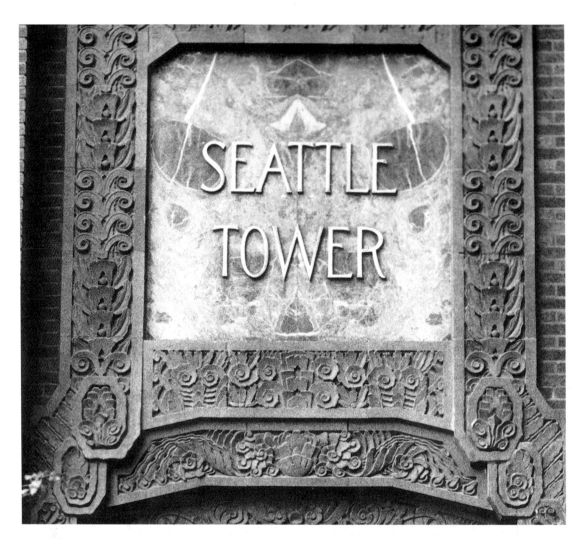

Seattle, Seattle Tower, 1218 3rd Ave. (J. W. Wilson for Albertson, Wilson and Richarson, 1928-29), exterior-detail.

skyscraper in the entire Northwest. In a particularly striking effect, the impression of verticality is enhanced by the stepwise narrowing of the tower towards the top at the same time as the color of the stone gets progressively lighter. Also of interest are the lobbies, where we find an unusual juxtaposition of regional and indigenous elements, Native American, Mayan, and Chinese, with ziggurat motifs, iron work, and crystal chandeliers.

Seattle has its theaters too, including, near the luxurious, neoclassic Four Seasons Olympic Hotel, the Fifth Avenue Theater. Entering the foyer is like entering a magic cave, all covered with bright red panels and gilded stuccos. Built in 1926 by Robert C. Reamer and J. L. Skoog as an exact replica of the throne room of the imperial palace in Beijing, it is no less extravagant than the more famous (and sumptuous) Mann's Chinese Theatre of Los Angeles, the "High Pagoda" of cinema.[41] Another movie house which is clearly of Deco style, the Egyptian Theater, at 801 East Pine Street, at the corner of Broadway, started life as a Masonic Temple. Literally: from one temple to another.

So here too, as in any self-respecting American city, there is a corner of "Movieland," not so obviously an institution, as in Los Angeles, nor as diffuse as that open air movie set which is Miami Beach, but yet still exuberant and imaginative enough to show us the splendors of the fabulous years of Deco.

89

Seattle, Seattle Tower, interior-detail.

LOS ANGELES

Here we are, at the penultimate stop of our journey, the most fascinating and the richest in imaginings which spring out from books and movies, and which make of Los Angeles the celebrated city of legends, keeping us "in a state of constant adolescence," as Charyn says, making us fall desperately in love with movie stars. Yes, we are in "Movieland," the fabulous capital which, in the collective imagination, has been from its beginning the fountainhead of dreams. Busby Berkeley, the master of magic, was well aware of it when he confessed: "In an era of breadlines, Depression and wars, I tried to help people get away from all the misery…to turn their minds to something else. I wanted to make people happy, if only for an hour."[42]

Again citing Jerome Charyn: "…if New York was the first twentieth century-city, cradled by Ellis Island and mongrels from all over the world…L.A. was the *second* 'World City, just as complex and cosmopolitan as any city of the past.' It was, in fact, the city of the future, 'a low-density Babylon, where the skyscraper was transmogrified into a million bungalows'" (259).

There is a place in Los Angeles upon which all fantasies seem to converge, namely, the fabled Sunset Boulevard. It begins downtown, at the end of what was the pueblo of the original town, runs along Echo Park and meets Hollywood Boulevard near Barnsdall Park, where sometime around 1917 the oil heiress Aline Barnsdall commissioned Frank Lloyd Wright to design a kind of artist's community, complete with theater, residences and other buildings. One of the few buildings actually completed was Hollyhock House (1919-20), intended to be Barnsdall's residence. However, the oil heiress lost interest in the project, was unhappy with the house, and barely ever lived there. In 1926, she donated the entire property to the city as a museum and park.

In this area, on the hills which extend beyond Los Feliz Boulevard, can be found some of the most important examples of the architecture of the twenties and the thirties, both Deco and International Style buildings, designed by Wright and by European émigrés such as Neutra and Schindler. The above-mentioned Hollyhock House, named after its stylized decorative feature, was Wright's first project in California, and one of the first with overt Mayan influence as well, creating an unmistakable style and a model for other residences. Also Mayan in inspiration, but of more imposing dimensions, and built with Wright's textile block system instead of poured concrete, is the Ennis-Brown House, which, like a temple, dominates the city from the top of the hills amidst green bushes and trees. Similar though smaller is Storer House, which repeats the motif of the Mayan temple. As with the three other textile block houses which Wright built in this period, the cast blocks are colored in the warm hues of local desert stone and decorated with regular repeated figures. Here too the natural is a decorative architectural element, in accordance with Wright's aesthetic canon.

Sowden House, on Franklin Avenue, at the corner of Normandie, is the work of Frank Lloyd Wright's son, Lloyd Wright, and it is among the most singular and characteristic of all these homes. Viewed from the front, it has the form of a horizontal block of a golden rose color, without any openings or windows, except at the center of the facade, where a superimposed structure of small, incised blocks frames a window as well as a semi-sunken entrance door. A similar structure on the opposite wall opens onto an enclosed courtyard garden. The form of the entrance seems intended to recall the grottos of 18th century gardens. The overall effect is that of an ensemble of parts linked together by an unusual harmony.

Other immigrant architects, including Neutra and Schindler, compatriots and rivals, worked in the same area. Among the houses designed by the former, who achieved a certain degree of renown in California, we can single out Neutra House, at 2300 East Silverlake Boulevard. Built in 1933 in steel and glass, according to

Los Angeles, Sunset Towers (later called St. James Club, and now The Argyle Hotel), the lobby.

the strictest canons of the International Style, the house was partially rebuilt by the architect's son, Dion Neutra, after a fire, and in the process has lost much of its original rigor. In the course of the following years, up to 1962, the elder Neutra built many homes in this area, following the same paradigm of essential and functional lines, without forgetting the principle of beauty as harmony of form and line.

Rudolph Schindler was less popular than Neutra, but not less original. In 1926 he designed Schindler House (at 833 North Kings Road in West Hollywood), where he innovated both with respect to building techniques, constructing walls from tapering concrete slabs with glass slits between, and spatial organization, giving the house an open feeling through the use of courtyards, glass-enclosed patios, and large-windowed sleeping porches. Olive House, at 2236 Micheltorena Street, was built on an isolated site in 1933. Here Schindler succeeded in blending the characteristics of the International Style with more traditional tendencies.

Back on Sunset Boulevard we find, at the intersection with Hollywood Boulevard, another legendary spot, the place where in 1916 Griffith built his set for *Intolerance*. It remained open for visits by fans of the tenth Muse until 1919 when it was demolished.

Continuing along Sunset Boulevard, near Western Avenue, we come up to the site of another historical landmark of the movie world, the place where millionaire William Fox built the sets for the movies of Theda Bara, the first quintessential vamp. A little further, at 6525, is a pink building, formerly the Hollywood Athletic Club, which witnessed the epic drinking binges and wild antics of actors like John Barrymore and Clark Gable. Other buildings have disappeared, including Alla Nazimova's "Garden of Allah". However, at the intersection with Crescent Heights, we find the still intact Hotel Château Marmont, which evokes, as the name suggests, images of ancient castles. Among its guests were famous stars of show business, such as the sublime Greta Garbo, Billy Wilder, Howard Hughes, and even Stravinsky.

Real and imaginary places intermingle in our memory, particularly in that part of Sunset Boulevard which even today is considered the most elegant and fashionable, the so-called Sunset Strip. Begun as a commercial center in 1924, it became notorious in the thirties for the Clover Club, frequented by Benjamin "Bugsy" Siegel. It was there that the playboy/gangster began the gambling successes which led eventually to the transformation of Las Vegas into a gambling and entertainment center in the Nevada desert, a place where, more than anywhere, reality and fiction form an inextricable knot. Even if we are not quite sure what we should "learn from Las Vegas" about the relationship between society and architecture — as suggested by Venturi, Scott Brown, and Izenour in their book that is still a source of countless debates — it is certainly true that with his Flamingo Hotel and Casino Bugsy created an inevitable reference point for those who want to comprehend the concepts of kitsch and postmodern.

The jewel of Sunset Boulevard, and undoubtedly one of the most harmonious constructions of California Deco, is Sunset Towers (later called St. James Club, and now The Argyle). Located at a sharp curve in the Boulevard, it was built by Leland A. Bryant in 1929 as an apartment building for the stars who worked in the nearby studios. Howard Hughes used to rent apartments for his girlfriends. Many show business personalities stayed there, or at the already mentioned Château Marmont, or in the other exclusive hotels along Sunset and Hollywood Boulevards, like the Beverly Hills Hotel, the legendary pink palace with its small orientalizing domes, and the Roosevelt, inaugurated in 1927, almost in celebration of sound movies, which hosted the banquet for the first Oscar ceremony in its Blossom Room in 1929.

Sunset Towers has the form of a block whose surface is lightened and articulated by vertical decorative elements. Here too we find the Deco leitmotif of the rounded corner windows associated with the streamlined look. Decoration is provided by a series of friezes at each setback, featuring floral, marine, and planetary motifs, but punctuated by more abstract chevrons and stacked half-disks, and in one case, by a pair of semi-draped figures. The interior, in the purest Deco style, is just as handsome, from the entrance hall and elevators, to the terrace overlooking the valley, complete with bar and a small, but graceful swimming pool, which is surrounded by lamps in the form of small, concrete palm trees.

As it goes through Beverly Hills, Sunset Boulevard becomes an avenue lined with tall, slender palm trees, decorated with flower beds, and surrounded by the most sumptuous villas of the rich and famous, a major tourist attraction. Starting from one of the largest and most

Los Angeles, Sunset Towers (later called St. James Club, and now The Argyle Hotel), the ball room.

extravagant mansions, the 50 room Greystone Mansion, built by oil magnate Edward Doheny, we turn up into the hills and come shortly to Bel Air and those inaccessible and often impracticable little streets which have hidden some of the "cult" houses, like Pickfair House, which belonged to Douglas Fairbanks and Mary Pickford, and the homes of Rudolph Valentino, John Gilbert, Marlene Dietrich, Ramon Navarro, as well as the town house where newspaper magnate William Randolph Hearst spent the last years of his life with his companion Marion Davies. Some of these mansions have now disappeared.

Passing through Westwood and Brentwood, Sunset Boulevard heads towards the sea at Santa Monica and Malibu. Of note in Westwood, where the splendid campus of UCLA is located, are some remarkable movie palaces, like the Fox Westwood Village (now Mann Village), designed by P. O. Lewis in 1931, the Bruin (1937, now Mann Bruin), one of the many examples of the rich California production of the Chicago architect S. Charles Lee, and finally the Crest on Westwood Boulevard. Close to Brentwood, on Shetland Place, there is another historical site for aficionados of the detective story: the apartment where novelist Raymond Chandler wrote two of his most famous Philip Marlowe books.

Chandler's hero loved to drive along this boulevard, just as his author loved to cruise through the city at night admiring the multicolored splendor of its neon lights. Chandler maintained that those lights were the most important thing in Los Angeles, and that a museum should be built to honor the inventor of the neon light. He used to say: "Now there's a guy who really made something from nothing. When you turn those lights off, the whole damn city disappears". Today his wish has been granted, and the Museum of Neon Art (MONA) has been built downtown between West Olympic Blvd and Grand St.

Like Marlowe, today's visitor to Los Angeles is plunged into that atmosphere, both real and fantastic, which dominates the whole city, so evocative, always shifting from reality to the fiction of literature and cinema. Chandler's books, starting with *The Big Sleep* in 1939, and the movies which have been made from them, perfectly blend the atmosphere of the film noir with Deco style. It is therefore through the eyes of this hard-boiled detective that we can truly discover the city and its most lurid secrets. Following Marlowe's trail, we arrive downtown via Wilshire Boulevard, lined with monuments to big

money. The central section of Wilshire Boulevard, which has rightly been called "Miracle Mile," is lined with prestigious hotels, office buildings, commercial centers, theaters, and movie houses. In recent years, the downtown area, as well as Wilshire Boulevard, which connects it to Beverly Hills, has considerably deteriorated, resulting in the decline of many formerly wealthy and prestigious areas. Hollywood Boulevard is now undergoing a similar fate, and is in danger of losing its heretofore unique character. In the past few years, however, there have been signs of improvement in the downtown area; many buildings are being restored, giving rise to the hope that measures will be taken to preserve and protect the place.

The Los Angeles Public Library is an example of this kind of initiative. The Library is an imposing building with a central tower topped by a small pyramid, covered with multicolored tiles. Onto the basic Beaux Arts structure, designed in 1922 by Bertram Goodhue and Carleton Winslow, has been grafted a blend of various exotic elements borrowed from, among others, Egyptian, Roman, and Byzantine styles. Not far away, in the Bunker Hill area, once the site of elegant Victorian mansions, we find the Biltmore Hotel, built in 1923 by Schultze and Weaver. The beautiful facade is built in Italian style, while inside, in the Cognac Room, there is some splendid Deco ornamentation by A.T. Heinsbergen, which dates from the end of the thirties.

Los Angeles is full of Deco buildings which can be more or less grouped into two large categories: Zigzag Moderne, more typical of the twenties, including tall buildings, towers, and skyscrapers as in the big Northeastern cities, and Streamline Moderne, more popular in the thirties, with lower, horizontal and curvilinear structures. To the first group belonged one of the jewels of Deco architecture, the Richfield Building, now demolished. Built in 1929 by Morgan, Walls and Clements, it was clad in bright black and gold terra cotta tiles. Some of the old elevator doors have survived, and have been incorporated into the new buildings now on the site.

With the loss of the Richfield Bldg, the most important Zigzag Moderne building still standing in Los Angeles is the Eastern Columbia Building (1929 by architect Claude Beelman) on 849 South Broadway, whose tower, sheathed in blue-green and gold terra cotta, boasts an impressive

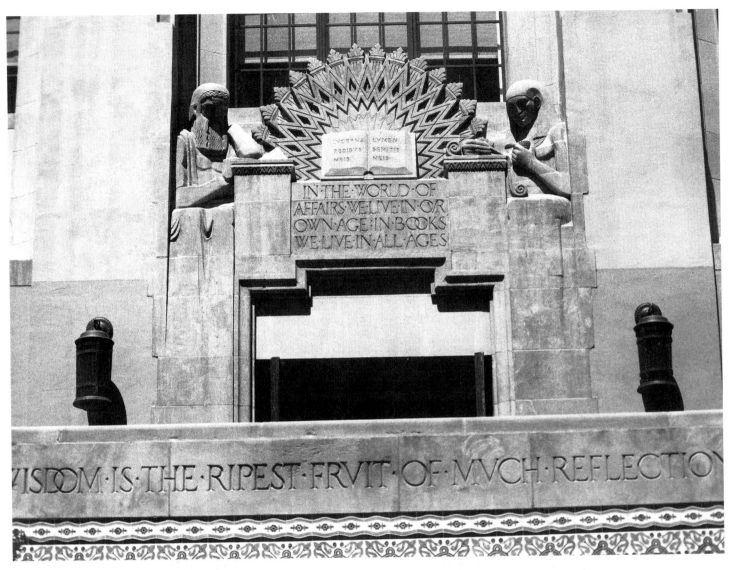

LVCERNA LVMEN
PEDIBVS SEMITIS
MEIS MEIS

IN·THE·WORLD·OF
AFFAIRS·WE·LIVE·IN·OVR
OWN·AGE·IN·BOOKS
WE·LIVE·IN·ALL·AGES

WISDOM·IS·THE·RIPEST·FRVIT·OF·MVCH·REFLECTION

96 *Los Angeles,* The Central Library of the Los Angeles Public Library, 630 West 5th St. at S. Flower (B. B. Goodhue and C. M. Winslow, 1925), main entrance-detail.

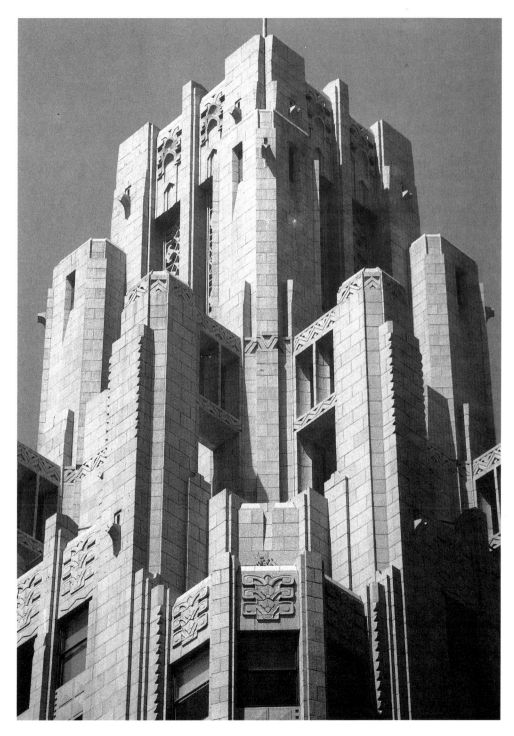

Los Angeles, Title and Guarantee Building Tower, 411 West 5th St. at S. Hill (John and Donald Parkinson, 1929-30).

clock and characteristic zigzag decorations at the corners. Also Beelman's work is the Garfield Building at 408 West 8th Street, characterized by the exquisitely detailed decoration of its main entrance. By contrast, at the Pacific Coast Stock Exchange, designed by Samuel Lunden for the Parkinson firm in 1929, it is symbolism which triumphs. Ornamentation of Egyptian and classical inspiration decorates the windowless facade. The sculptures represent Finance uniting Science and Industry. With an entrance on First Street at the corner of Spring, the Los Angeles Times Building, (now Times-Mirror Building) designed in 1931 by Gordon Kaufman, blends the original Moderne style with recent additions. The nearby Selig Retail Store Building (now a bank), designed by Arthur E. Harvey in 1931, has bright geometric decorations against a striking background of gold and black terra cotta.

One of the outcomes of clothing manufacturer James Oviatt's visit to the Paris Expo was the planning of the Oviatt Building, built in 1927 between South Olive and Sixth Street. Most remarkable were the glass decorations by René Lalique, who obtained from Oviatt his most important commission in the United States. Some of Lalique's work, like the elevator doors with their orange fruit motifs, were rescued from the state of disrepair into which the building, like other downtown buildings, had fallen in the sixties, and now shine in the elegant Rex Restaurant which occupies the site.

A stroll downtown will reveal many other Deco structures, some commonplace, others deserving of attention. We shall mention just a few, leaving it to each visitor to make up her own itinerary. City Hall (1926-1928) is dominated by a monumental tower with a stepped pyramid at the top, and decoration in various styles, including Zigzag Moderne. The First Business Bank (originally the Southern California Edison Building), in the Bunker Hill district, has interesting reliefs on the corner portal, while inside a mural by Hugo Ballin celebrates the "Apotheosis of Power". The Union Passenger Terminal, built in the style of an old Spanish Mission, with Aztec influences and some Deco touches, is a transitional building combining Old West style and modern design. The Title and Guarantee Building (1931; now Guarantee Trust), by John and Donald B. Parkinson, at the corner of South Hill and West Fifth Streets, is also worth noting, and, by the same firm, the L.A. Branch Federal Reserve Bank of San Francisco, with its beautiful reliefs. Finally, let us

mention the nearby Bankers Building (lateral International Center, and now L.A. Jewelry Center) of 1930 by Claude Beelman and several other edifices in the area between Bunker Hill, Broadway, Olive and Figueroa.

A separate set of considerations apply to those buildings designed for industrial use, of which there are a number of significant examples beyond the downtown proper. Perhaps the most interesting is Robert V. Derrah's Coca-Cola Bottling Company Plant (1935-1937), at South Central and 14th Street, a notable example of streamlining in the Nautical Moderne style. Resembling an ocean liner, complete with bridge, port-hole windows, gangways, pipe railings, and other nautical elements, it could have been a movie set, built perhaps for a musical like *Following the Fleet* with Ginger Rogers and Fred Astaire. A foreshadowing of Pop Art can be seen in the two gigantic Coca-Cola bottles near the building. Derrah used the same nautical theme in 1936 for an unusual building at 6671 Sunset Boulevard, the Crossroads of the World, whose "stern" contains several shops built in various styles representing different countries of the world. The flourishing automobile industry was responsible for many important buildings during this period, some of the most extravagant being devoted to the production of tires. Such is the case for the Samson Tyre and Rubber Bldg. (1929), designed by Morgan, Walls and Clements in a bizarre, exotic style which might be characterized as Assyro-Babylonian. Now called "The Citadel", it is used for expositions and other public events.

Returning to Wilshire Boulevard, and heading from downtown towards Beverly Hills, we come upon the Park Plaza Hotel, located in the historic Elks Building (1924). Its massive base is lightened by large triform windows with slender columns and chiseled capitals which echo the style of the portal. The middle section of the structure is decorated with statues placed at the corners, while the central tower, with a superimposed smaller tower, is in its turn adorned with large statues at each of the four corners. Inside there is an imposing lobby with a grand staircase leading to the upper floors; the ballrooms, the spacious restaurants and lounges are decorated with luxurious Deco motifs on the walls and ceilings, tapestries and chandeliers. It is still possible to breathe the atmosphere of its golden age, when personalities as diverse as Bing Crosby and Eleanor Roosevelt were numbered among its guests.

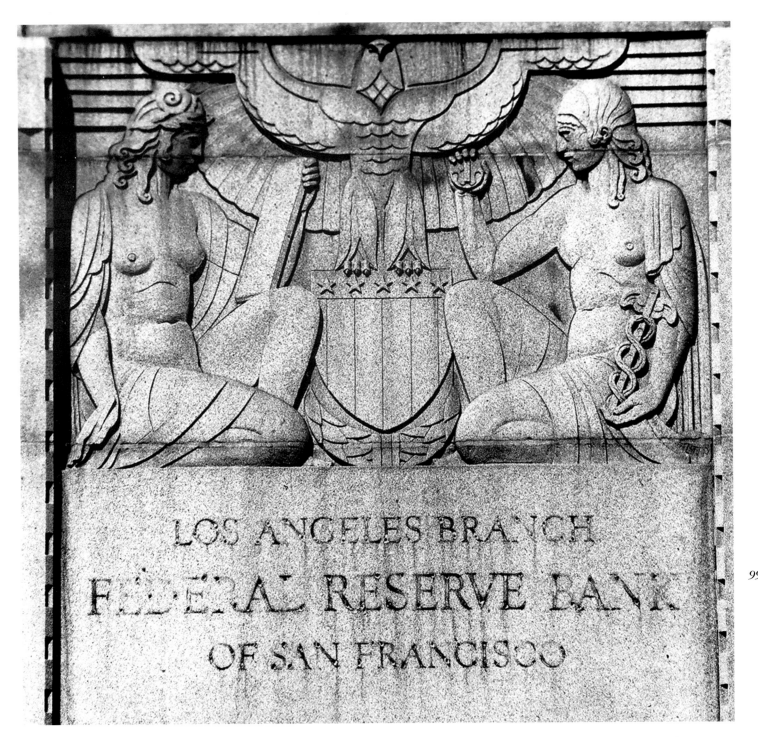

LOS ANGELES BRANCH
FEDERAL RESERVE BANK
OF SAN FRANCISCO

Los Angeles, L.A. Branch Federal Reserve Bank of San Francisco, 950 South Grand Ave. (John and Donald Parkinson, 1930), detail.

Los Angeles, L.A. Branch Federal Reserve Bank of San Francisco, detail.

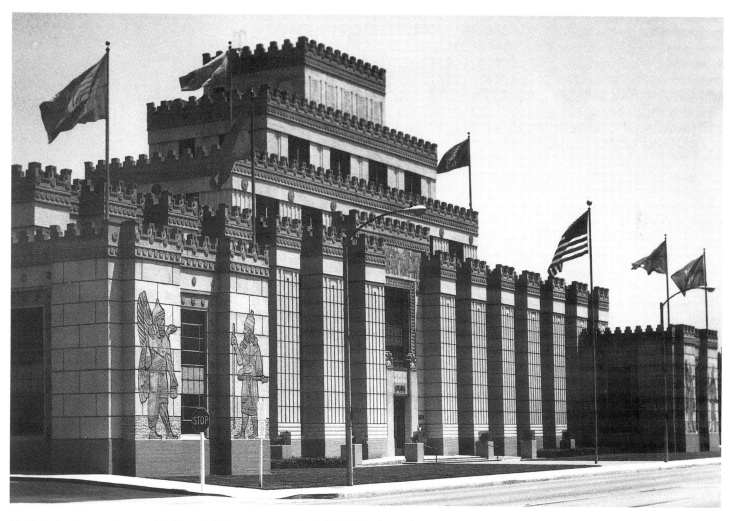

Los Angeles, Samson Tyre and Rubber Building (now the Citadel), 5675 Telegraph Rd., Santa Ana Freeway (Morgan, Walls and Clements, 1929).

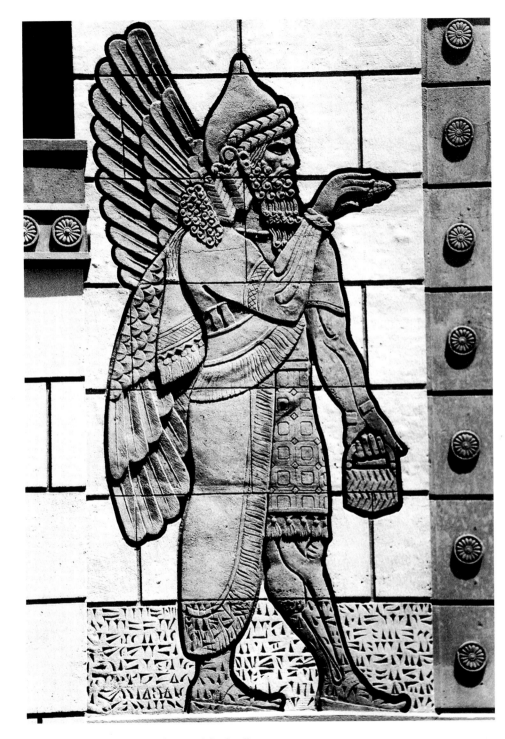

Los Angeles, Samson Tyre and Rubber Building (now the Citadel), detail.

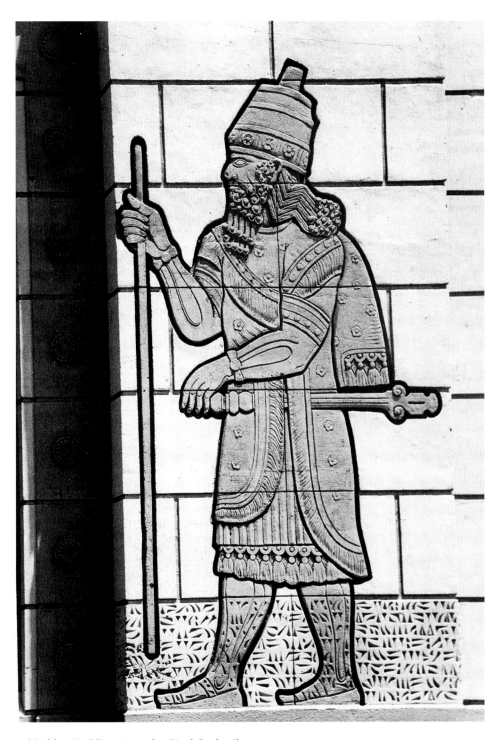

Los Angeles, Samson Tyre and Rubber Building (now the Citadel), detail.

But without a doubt, the Deco jewel of Wilshire Boulevard is the Bullock's-Wilshire Department Store Building, built in 1928 by John and Donald Parkinson, with relief sculptures by George Stanley. Its distinctive tower, clad in green oxidized copper and buff terra cotta, and exhibiting a rich pattern of decorative bands and geometric ornament, is a local landmark. The interior is no less striking, with its elevator doors of beautiful modernistic design, and its murals and frescoes celebrating various modes of transportation. Inaugurated in 1929 as the city's most elegant department store, it housed a variety of international boutiques as well as a tea-room frequented by the most fashionable and sophisticated women in town, who profited from its slight remove from the downtown area to arrive by automobile. The deterioration of the area has caused the store to close its doors for a lengthy restoration. But it is not as a department store that Bullock's will reopen, but as the Library of South Western University School of Law which is located nearby. Once again the maxim that its creator had inscribed over the portal will come true: "To build a business that will never know completion."

Not far away are two other department store buildings, Desmonds (now Wilshire Tower) and the May Company Store, both with curvilinear corner entrances. The former, designed by Gilbert S. Underwood between 1928 and 1929, has an eight story tower in ziggurat style on the side facing Wilshire, at 5514. There is an imposing lobby preceded by an entryway with a terrazzo decoration underfoot and reliefs overhead suggesting, with both real and fantastic nautical motifs, a marine theme which is confirmed by the predominant use of blue in various shades. On the other hand, the perfect Streamline styling of the May Company Building shows it clearly to be of later date. Built between 1939 and 1940 by the architect Albert C. Martin with the collaboration of Samuel A. Marx, it combines a simple three-story rectangular structure with, at the corner of Wilshire and Fairfax Avenue, a gilded cylindrical tower strikingly set off by a black granite frame bearing the name "May Co." in gigantic letters. As David Gebhard and Robert Winter put it: "The corner gold tower (really a sort of elegant perfume bottle) with its sign is *the* architecture of the building, especially when lighted at night" (198). Today this store is also closed, abandoned after the serious damage caused by the recent riots in downtown L.A.

As mentioned earlier, Wilshire Boulevard is rich with Deco buildings, some truly worth seeing, such as the tall tower of the Wilson Bldg, between Wilshire and La Brea (by Meyer and Holler, 1929), and the Khorram Building (1929), now Security Pacific Bank, at 5209, which has black and gold decorations which pick up the ziggurat motif. But the other complex which, with its turquoise terra cotta and ornamental ziggurat motifs, somewhat recalls Bullock's is the Wiltern-Pellissier Building at 3780-3790 Wilshire. In one part, it houses the fashionable Atlas Bar and Grill, whose Deco-based décor successfully incorporates post-modern elements as well. Further along, on the north corner, is the entrance to the Wiltern Theatre (originally the Warner Brothers Western Theater), which was built in 1930 by G. Albert Lansburgh and which, after a recent restoration, is again providing a venue for concerts and musicals. The entrance and the ticket office greet us with lavish decorations in aluminum and an elaborate play of lights over the sunburst motif on the low ceiling. Inside is a complex décor in pastel and gold below a ceiling in warm yellow-orange dominated by a stylized sun radiating beams in the shape of skyscrapers. The stage, with its splendid fire curtain painted by Anthony B. Heinsbergen with a cubist-deco representation of the "Vision of the Heavens," is surrounded by columns and vertical moldings topped by geometric elements which recur on the cornice and double as light fixtures. The spectacular ceiling in the lobby is also by Heinsbergen.

We are, it must not be forgotten, in the heart of Movieland, and its movie palaces and theaters are its great monuments to fantasy and entertainment. From downtown to Hollywood, from Wilshire Boulevard to Westwood and Santa Monica, there was an enormous number of theaters built by the great impresarios from the end of the twenties on, and many can still be visited, while others are reopening after being restored to their former splendor. In dealing with these monuments of show business, Hollywood, entertainment industry that it is, gives the best of itself in a montage of styles. Here in fact Art Deco is not pure, but is mixed with French baroque, Italian Renaissance, and the splendors of Spanish Colonial, among others, but it is the orient which proves to be the richest and most fantastic source. In addition to the downtown movie houses, notably the Mayan Theatre (1927) of Morgan, Walls and Clements, with its splendid

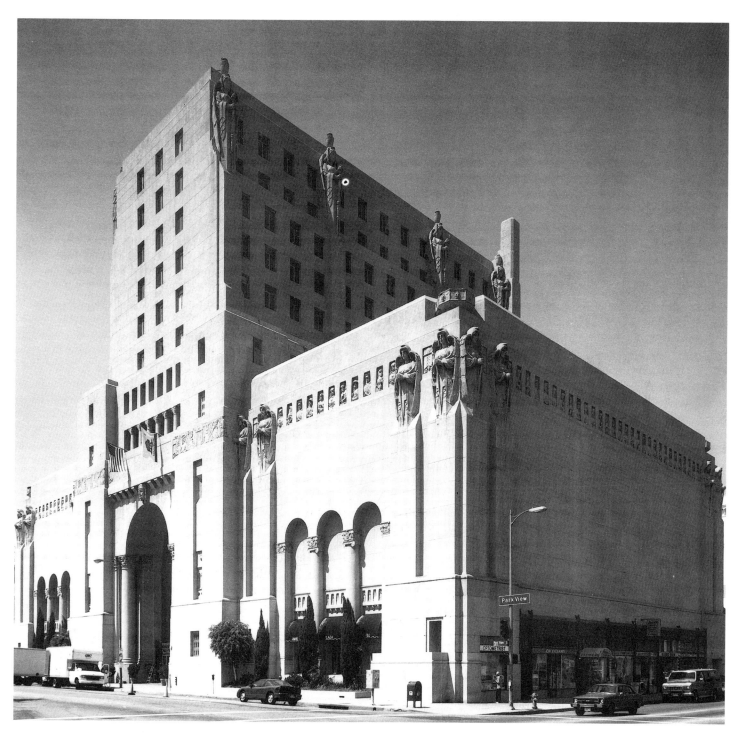

Los Angeles, Park Plaza Hotel (Elks Building), 607 South Park View St. (Curlette and Beelman, 1923-24).

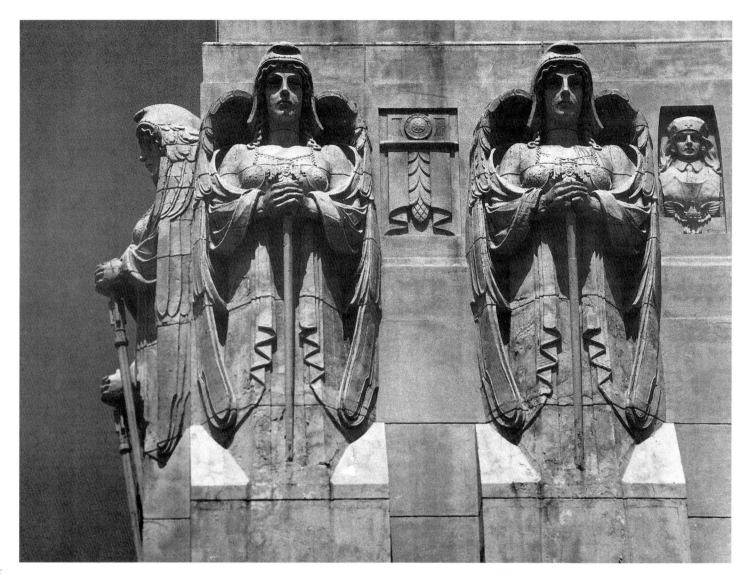

106 *Los Angeles,* Park Plaza Hotel (Elks Building), detail.

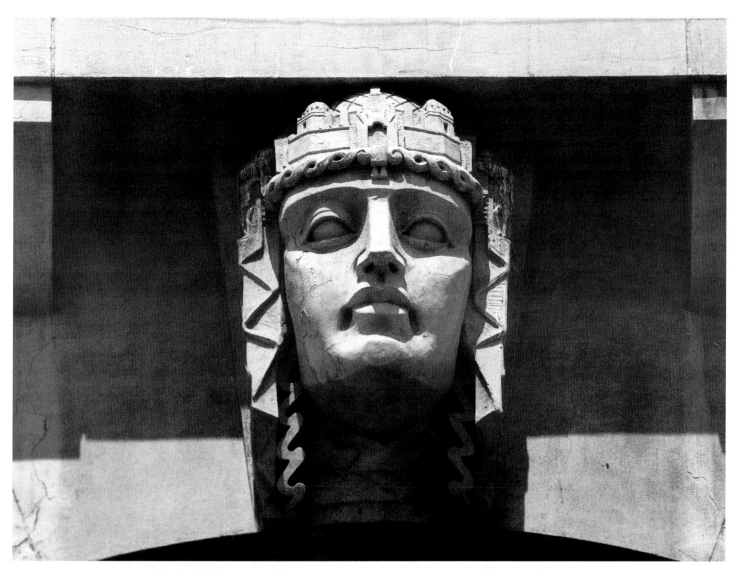

Los Angeles, Park Plaza Hotel (Elks Building), detail.

polychrome decorations, the tour can continue with the El Rey Theatre (1928, Cliff W. Balch), at 5519 Wilshire Boulevard, before going on to Hollywood Boulevard.

The first movie house built by impresario Sid Grauman, "Roxy West of the Rockies," was the Egyptian Theatre, 6712 Hollywood Boulevard, designed by the architects Meyer and Holler (1922). It was here that the tradition of the great Hollywood premieres began with the silent version of *Robin Hood* starring Douglas Fairbanks. The stars arrived in limousines and walked towards the entrance on a red carpet while spotlights illuminated the scene and the sky. The Egyptian theme of the theater was emphasized by painted columns, sarcophagi and sphinxes, while the usherettes were dressed as Cleopatra. This was the beginning of Hollywood's reign as the fantasy capital of the country, the beginning of — paraphrasing Venturi and Company — a long period of "Learning from L.A."

The Egyptian has been closed for some years, and it can only be hoped that it too will someday soon benefit from a miracle like that which brought the El Capitan back to being among the most frequented theaters. Built in 1926, and remodeled several times with the addition of colonial elements on the exterior and echoes of far-away India on the interior, the El Capitan hosted the premiere of Orson Wells' *Citizen Kane* in 1942. Recently, the theater has devoted several evenings a week to the successful revival of the practice of having live vaudeville performances before a film showing.

In 1927, also through the efforts of the astute Sid Grauman, the movie palace which was to become synonymous with Hollywood, namely Grauman's (now Mann's) Chinese Theatre, was inaugurated with the premiere of *King of Kings* by Cecil B. De Mille. At the same time, there began the practice of having the stars leave their hand prints and footprints in wet concrete, beginning with the prints of Norma Talmadge and the most famous couple of those years, Douglas Fairbanks and Mary Pickford. The Chinese Theatre, also a project of Meyer and Holler, must be the most fanciful interpretation of a Chinese Temple ever constructed in the West, with its vermilion columns topped with fanciful masks and gilt capitals. The interior was decorated by John Gabriel Beckman, to whom we also owe the murals of the Avalon Theater on Catalina Island.

But the gem of California Deco theaters is the Pantages (6233 Hollywood Boulevard) with its capacious seating space and its large, evocative foyer. The lavish Art Deco design, the work of Marcus Priteca (1929), sets the tone on the outside, while the marble and bronze of the entrance hall convey a sense of luxury. And once inside, the most exotic and daring motifs are mixed together. The double staircase lined with vaguely Egyptian and Assyro-Babylonian statues, the vaults with their zigzag geometric design, the lighting fixtures, the carpets, combine to evoke the set of the most lavish costume epic. The Pantages opened with the premiere of *Floradora Girl*, starring Marion Davies, with Al Jolson acting as master of ceremonies, and from 1949 to 1959 it was the scene of the annual Academy Awards ceremony. Even the name of Howard Hughes is associated with the Pantages: he acquired it for a brief period in the sixties.

Among the other venues given over to arts and entertainment, we cannot fail to mention the Hollywood Bowl, an open air amphitheater, superbly sited in a park at the foot of the hills, with a shell-shaped stage and superb acoustics which permit the enjoyment of music under the starry skies of Los Angeles. Planned in the twenties, the original design for the shell, with its progressively opening concentric circles, was the work of Frank Lloyd Wright's son, Lloyd Wright. A splendid fountain with a statue of the goddess of music on top was added to the entrance of the park in 1940 (sculptor George Stanley).

There are still other Deco buildings of note to be seen in Hollywood, including the one which houses Frederick's (6606 Hollywood Boulevard), the Max Factor Building (1666-68 Highland), an example of French Deco by S. Charles Lee, the First National Bank at the corner of Hollywood and Highland, and the Vine Tower Building between Yucca and Vine. Not to be forgotten is that inexhaustible dream factory which is CBS studios, still today housed in the International Style building designed for them in 1937-38 by William Lescaze and E.T. Heitschmidt (6121 Sunset Boulevard).

High on the hill, near the celebrated insignia of "Hollywood", we can visit the Griffith Observatory and Planetarium, a Moderne structure with classical and Deco elements, begun in 1934 by Austin and Ashley. Descending towards the sea between Santa Monica and Venice, we come to some examples of Beach Deco, the Shangri-La Hotel and the Cadillac Hotel. Finally, we can go on to Catalina Island, the private paradise of the Wrigley

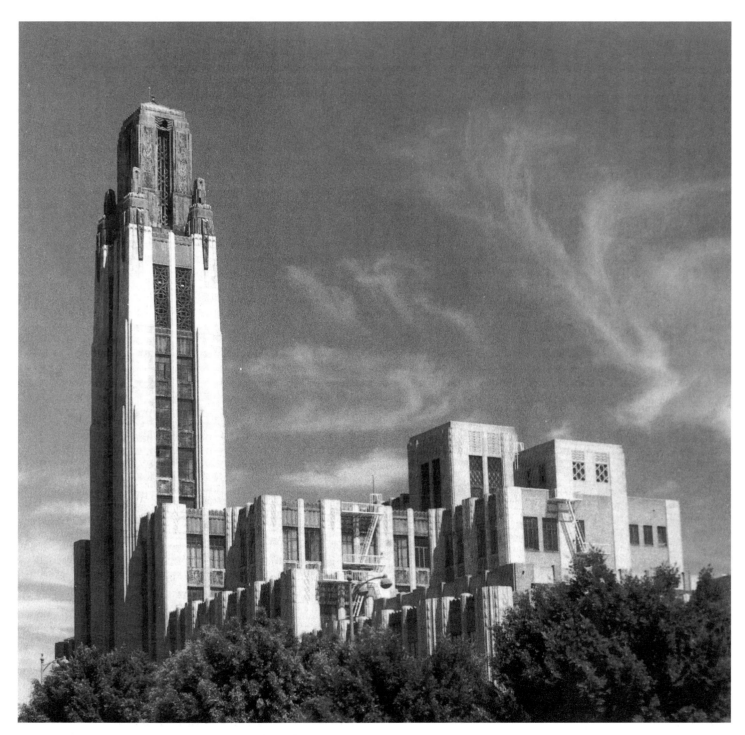

Los Angeles, Bullock's Wilshire (now South Western University School of Law Library), 3050 Wilshire Blvd. (John and Donald Parkinson, 1928).

family, to see that masterpiece of Nautical Moderne, the Avalon Casino and Theater, a monument to play and pleasure, designed in 1928 by Rowland Crawford with a combination of classical, Moorish, Venetian, and Spanish elements. The white, circular structure with maroon roof and trim has windows and terraces all around. The interior is decorated with imaginative murals by John Gabriel Beckman. Over the stage is a Venus rising from the shell, while the curtain is painted with a nude male figure on the crest of a wave. On the backdrop there is a map of the island representing "The Flight of Fancy Westward." Other paintings by Beckman adorn the side walls of the auditorium.

Although this visit to Los Angeles concludes our specific discourse on the architecture of Movieland, our journey through American Art Deco is not done. The fable of Deco in America is endless, and could take us from north to south, and from coast to coast. But we have chosen to make the last stop in a small paradise, a virtual open-air museum housing priceless if belated Deco gems.

MIAMI BEACH

Many of the rules that have been proposed for European Deco or for the American Deco of the great cities seem, at least in part, to be contradicted when, for the last leg of our journey, we head to Florida, in search of what has been called "Tropical Deco." In Miami Beach, we will find not only some attractive Deco buildings, but also an entire area with such a high and conspicuous concentration of such buildings that it has become known as the Art Deco District. There are no imposing skyscrapers like the Chrysler, no grand complexes like Rockefeller Center, no unique jewels like Bullock's in Los Angeles, but there is instead a homogeneous ensemble of hotels, apartment buildings, movie houses, theaters, restaurants, coffee houses, and nightclubs which together have contributed to making today's Miami Beach both a trend-setting destination for the "beautiful people" and an obligatory port of call for students of modern and post-modern architecture.

At the turn of the century, this famous beach resort was nothing but a labyrinth of mangroves. Its development as a beach resort began in 1910 and was largely the work of Carl Fisher, a millionaire developer. Fisher focused his attention on the northern part of the island, which he turned into an island paradise for the well-to-do. The southern part, on the other hand, was turned over to the Lummus Brothers, who developed it as a middle-class resort. And, because of the abrogation of contractual restrictions on Jewish access which were enforced elsewhere, it became largely a resort for the Jewish middle-class.

After a halt caused by World War I, development in the area took off during the boom years of the twenties, only to be slowed again by the depression. But by the mid-thirties, south Florida had emerged from the depression still afflicting the rest of the country, in a second boom due mainly to the growth of the tourist industry. This boom lasted until the early forties when it was again halted by American entry into the Second World War, and it was during this latter period that Deco architecture took hold in south Miami Beach.

Given the relatively small lot sizes established by the developers, and the focus on middle-class tourism, development in south Miami Beach focused primarily on small hotels and apartment buildings. And because most of the building was done in a relatively short period of time, by a relatively small number of architects, builders, and artisans, who worked together and shared a common purpose, the result was a remarkable uniformity of style. The architects were attracted by the Deco style which by that time was widely diffused, had popular appeal as something new, and emphasized the use of new, mass-produced and relatively inexpensive materials. The Art Deco district was born.

After the war, the development boom in Florida resumed, but developers focused their attention on other parts of the state. Newer, bigger, and more "modern" hotels attracted tourists away from Miami Beach. The area went into decline. The hotels were converted to rooming houses and residence hotels for elderly retirees. Eventually, some were closed and even demolished. By 1976, the area "was considered a disgrace to the city, because of its cheap neon lights, 'funny shaped' buildings, and the signs along Ocean Drive blaring 'rooms $5 a week.'"[43] Plans were afoot to raze the whole district and make a new start.

Into this picture stepped Barbara Capitman, a recent arrival to the Miami area who had rediscovered the romance and charm of this forsaken part of the city. She soon became a champion of Miami Beach Deco, managed to marshal both local and national support, including that of well-known post-modern architects Robert Venturi and Denise Scott-Brown, and launched a campaign which led, in 1979, to the official designation of a portion of the area as the Art Deco District, and to its entry in the National Register of Historic Places.

There followed the beginning of the Deco Revival, an effort both to revitalize the Miami Beach district, to rescue it from the sorry state into which it had fallen, and simultaneously, to repair the reputation of the Art Deco style itself. A small group of courageous developers, led by

Capitman's son, Andrew, undertook the restoration of some of the buildings in the district. Although the restoration effort was in many respects faithful to the original forms, there was also an effort to "jazz up" the buildings, to bring the moderne up to the speed of the post-modern. The most notable example of this updating was the informal adoption of what has come to be called the Deco Revival palette, a set of saturated pastel paint colors chosen by the designer Leonard Horowitz, and intended both to liven up the facades of the restored buildings, and to enhance the stylistic unity of the district. The revival effort received a major boost when the producers of the sleek and highly popular television program *Miami Vice* chose to feature the district. This was followed by a series of ads by the likes of Calvin Klein, and before long the district was on the map of the jet set and the in-crowd. Deco — with a post-modern twist — was back in style. Anyone who ventures out onto Ocean Drive or Collins Avenue today, or strolls along Washington or Jefferson Avenues, cannot help but marvel at the world of sunshine and color which is there to be discovered, a world in which architecture and design are in harmony with the natural setting, creating a luminous unity of great appeal. The lively, contrasting colors — enhanced by the Deco revival palette — are perfectly in character with the tropical atmosphere of south Florida, where a luxuriant nature has contributed to the ornament of manmade structures with stylized flowers, exotic plants from the nearby Everglades, and colorful animals, including the vivid pink flamingo, a virtual symbol of the city. There are, for example, flamingoes in the mural by Earl LaPan in the attractive lobby of the Victor Hotel (designed by L. Murray Dixon) at 1144 Ocean Drive, or on the sculpted plaque on the facade of Albert Anis's Abbey Hotel, with its distinctive tower, surmounted by two stylized flower stalks, above the corner entrance.

Light pink and mauve, periwinkle blue, cobalt blue and aquamarine, chrome yellow and lemon yellow, bright white, beige, orange, and various pastel shades are used in mural paintings and in the glowing facades of houses and hotels, so that the effect of a stage set is only accentuated by the bright daylight. At night, on the other hand, the outlines of buildings, towers, and cigarette- and pencil-shaped hotel signs are lit up with the metallic light of multicolored neon. Here, even more than in Los Angeles, the influence of cinema on architecture and vice-versa is visible in the buildings, as if the architects were also and above all (in reality this was often the case) great set designers.

In spite of a decidedly eclectic orientation in the choice of styles (Moorish, Spanish colonial, Southwestern and pueblo, Mediterranean, Mayan, Egyptian and so on), the general effect is quite coherent. There is a limited set of prototype structures and decorative elements which recur with small variations from building to building in a harmonious symphony: structures of moderate height and great simplicity of line, blending the hard geometry of the International Style with the softness of streamlining.

This fusion can be seen in the use of both convex and angled corner windows, horizontal and vertical bands, and incised, decorated moldings on entrance doors and parapets. The punctuation of block structural elements with glass endows many of the facades with a pleasant rhythm. In addition, able craftsmen have created ornate terrazzo compositions on the floors of entryways and lobbies. Equally admirable are the murals, where the flair of the artists (among whom we should mention Earl LaPan and Paul Silverthorne) takes its inspiration from the most varied exotic and indigenous sources, and the most vigorous flora and fauna.

There were many architects who made major contributions to the development of Miami Deco, but the names of L. Murray Dixon and Henry Hohauser stand out. In spite of local prejudice and even hostility — they were in fact often considered mere manual laborers or second-rate artists — these architects received national and international recognition from notables like Philip Johnson and Robert Venturi. This belated recognition contributed to the preservation of the Deco District, no longer regarded as an example of bad taste in architecture, but rather as having played a determining role in the history of American design.

L. Murray Dixon, who came to Miami in 1928 after working in New York with the firm of Schultze and Weaver, is credited with, among other buildings, the design of some of the most popular hotels, such as the already mentioned Victor Hotel, the Marlin, the Senator, the Ritz Plaza, as well as the Flamingo Apartments, which have been restored and given a playful application of the new Deco Revival color scheme, highlighted by the typical circles and by vertical and horizontal bands.

Henry Hohauser, trained at the Pratt Institute in Brooklyn,

came to Florida in 1932, still under the heady influence of the Modernism of the Chrysler Building. He was also influenced by the fairs of the period, particularly the Chicago World's Fair of 1933. His work in Miami includes, among others, the Cardozo Hotel, the Colony, and the Essex House on Collins Avenue (1938), a typical example of Nautical Moderne, with porthole and octagonal windows, a horizontal line accentuated by cantilevered sunshades (the so-called "eyebrows"), and a rounded corner entrance surmounted by a masthead-like finial serving as a sign.

Also by Hohauser are the Carlton Hotel, the Greystone, and the Taft — the facade of the latter richly decorated with floral and geometric motifs and painted with a warm orange — as well as the apartment house at 850 Jefferson Avenue, with the ubiquitous cantilevered sunshades here accented by color. This building also has corner windows and colored waves running horizontally along the parapet and a vertical frieze on the facade, which is surmounted by a sort of small temple framing a yellow sunrise.

In addition to Dixon and Hohauser, a number of other architects worked in the district, including Albert Anis, Thomas Lamb, Anton Skislewicz, John and Coulton Skinner, and Robert E. Collins, among others.

We can begin our visit to the Miami Beach Deco District on Ocean Drive in order to look at some of the hotels which are now attracting such a rich and famous clientele.

The Breakwater Hotel at 940 Ocean Drive, built in 1939 by the architect Anton Skislewicz, has an attractive facade which was clearly influenced by the modernism of the New York World's Fair. The two symmetrical wings are joined at the center by a projecting tower structure, which carries the name of the hotel on both sides, in the flamboyant manner typical of some movie signs. The use of blue, white and yellow to create decorative accents — in contrast with the original color scheme in solid white with a few pink bands — illustrates the new approach to color schemes adopted in many of the revival style restorations. By night, the tower and sign are elegantly illuminated with neon lights. This is a typical example of Beach Deco: the architectural lines are perfectly suited to the natural context, and the slender palm trees in front seem to echo the verticality of the structure. The Breakwater shares with the neighboring Edison Hotel (designed in 1935 by Henry Hohauser) a swimming pool

with a mosaic image of Neptune on the bottom.

The Cardozo Hotel, 1300 Ocean Avenue (by Hohauser, 1939), has had a special place in the recent history of the area. It was one of the seven hotels which constituted the original nucleus of the current Art Deco District. And it was in the Café Cardozo, just off the lobby of the hotel, that visitors could sample the ice cream sundae called Deco Delights, a name which acquired symbolic meaning and came to be applied to the whole district, notably as the title of Barbara Capitman's book on the subject. The streamlined Cardozo — carried along by eyebrows, large corner windows, and the street-level portico — seems to sweep around the corner on which it stands.

Also dating from 1939 is the Governor Hotel on 21st Street, another successful design by Hohauser, whose streamlining effects, notably a curvilinear stainless steel canopy and sign over the door, give it a family resemblance to the Cardozo. At 630 Ocean Drive, we find another example of Hohauser's work, the Park Central Hotel (1937). Strong decorative bands in mauve and lavender together with green pinstripes and a dazzling white ground (colors chosen by designer Leonard Horowitz during the restoration) make of this one of the signature buildings on Ocean Drive. Above the entrance are three octagonal porthole windows, and four white circles on the parapet contribute to the visibility of the Park Central from a great distance at sea. Next door, the smaller Imperial Hotel (at 650, by L. Murray Dixon, 1939), which shares the same color scheme, has a gently stepped parapet and vertical aquamarine bands with a floral motif. The Saint Charles (now the Avalon Hotel, at 700, built in 1941 by Albert Anis) is another Ocean Drive attraction due to the austere geometry of volume and line, and to the unusual rectangular corner tower with corner windows, showing clearly the transition from the curvilinear structures of the thirties to the rigid geometric forms of the forties. Also by Anis on Ocean Drive, the Waldorf Towers (1937) is another corner building, but this time with a strong streamlined look, accentuated by the continuous "eyebrows" and an unusual, lighthouse-like, cylindrical tower, which is accented at night with phosphorescent neon. The lobby has a decorative terrazzo floor, together with mirrors and light fixtures exhibiting pure Deco geometries.

The exterior of the small Colony Hotel at 736 Ocean Drive, one of Hohauser's early projects, is cream and

brown, with a vaguely Mayan frieze along the parapet, while in the lobby there is an excellent Ramon Chatov mural in the manner of Diego Rivera over the polished green Vitrolite fireplace. Also worthy of visits are the Bentley, at the corner of Fifth, the Clevelander at 1020, the delightful Carlyle at 1250, and the Cavalier at 1320.

Moving over to Collins Avenue, the other important street in the district, we come first, at number 1200, to the Marlin Hotel, designed by L. Murray Dixon in 1939, and restored in 1991. The facade is in perfect Deco manner, with typical details set off by emphatic polychrome bands, and outlined at night by cobalt-blue neon. In this case, the neon lights are a recent addition, but they can be found, as we have seen, on many other buildings and add a characteristic accent to nights in the Deco District. Chamfered corner windows once again underscore the curvilinear movement of the facade and the sides.

Midway up Collins Avenue, there are three fine examples of Miami Beach Deco which, both because of their height — exceptional relative to the neighboring buildings — and their unusual pinnacles or finials, can be seen from a considerable distance. The Ritz Plaza (at 1701, designed by L. Murray Dixon in 1940) has a small tower in pure French Deco style, while the structure crowning the Delano (at 1685, designed by Swartburg, 1947) has, with its four fins, a space-age look. Finally, the National, designed by Roy. F. France in 1940, is surmounted by a small temple with a silver cupola. The Ritz Plaza was the site of the first World Congress on Art Deco, held in 1991. But perhaps the emblem of Collins Avenue is the corner tower of the Tiffany Hotel, with its metallic spire and its bright sign, another remarkable building by L. Murray Dixon (1939). On 21st Street, at 336, the Plymouth Hotel seems to be launching its blade-like tower from the middle of a convex central block which is flanked by two cubes. A simple and elegant structure designed by Anton Skislewicz in 1940, its characteristic outline adorned the first poster used to promote the emerging Deco District in 1977. The large circular lobby is decorated with a tropical style mural by Ramon Chatov. For entertainment, we can go to Washington Avenue, where there are both movie houses, such as the Cameo Theatre (by Robert Collins, 1936) and the Cinema Theatre (originally the French Casino), and restaurants such as The Strand (formerly, The Famous). The district also has residential buildings, like the Ed Lee Apartments on Pennsylvania, designed by

Hohauser (1936), a simple but lively building of varying heights with floral and streamline decorations in green and orange. Also of note, the Helen Mar Apartments at 2421 Lake Pancoast Drive, designed by Robert E. Collins in 1936 and restored in 1988 by J.P. Friedman. The block-like edifice is animated by a variety of decorative elements, including colored friezes, vertical lines, and corner windows. There is a small tower at the top, and the doors are flanked by horizontal bands of black Vitrolite.

Lincoln Road, now in part a pedestrian mall, has many stores, movie houses, and public buildings. Many other structures in Miami Beach would merit at least a mention, including reconstructions faithful in form and in spirit, such as Deco Plaza, between Fifth and Euclid, a project of Leonard Horowitz. But we must leave to the curious and attentive traveler the pleasure of choice and discovery.

In the area of Collins Park, there is another harmonious building by Hohauser, the Collins Park Hotel, which blends delicate hues of rose and green with geometric decorations. The Bass Museum of Art (2121 Park Avenue, designed in 1930 by Russell T. Pancoast) seems to carry us back to the style of Frank Lloyd Wright with its low Mayan-style construction. Bas-reliefs above the doors by the sculptor Gustav Bohland depict a stylized pelican with spread wings, recalling such vintage Deco motifs as the frozen fountain, the fan, the palm tree, and the sunburst.

We will close our journey with some examples of Deco in the greater Miami area, beyond Biscayne Bay. One of the oldest Deco buildings, not only in the Miami area but anywhere, is the Scottish Rite Temple, built by Kiehnel & Elliott in 1922 in Egyptian style, inspired by the fashion for things Egyptian which was sparked by the discovery of the tomb of Tutankhamen. Another building born as a fraternal lodge, and later transformed to other uses (most recently the Boulevard Shops), is the Mahi Shrine Temple. Designed in 1930 by Robert Law Weed, its decorations employ elements of the local flora and fauna, in addition to representations of Seminoles sculpted on the side of the limestone facade.

At the time of this writing, the fate of this building is uncertain, as is that of the nearby Sears Department Store (by Nimmons, Carr, and Wright, 1939). Let us hope that the wrecking ball will not strike down these splendid examples of Deco architecture, whose richness and variety constitutes a part of the historic and artistic tradition of America.

Footnotes

[1] Marina Isola, "Deep in the Heart of Dallas, Art Deco Deluxe," *New York Times*, Sunday, 12 November 1995, 50.

[2] See generally, Carl Bode, ed., *American Perspectives: The United States in the Modern Age* (Washington, D.C.: USIA, 1990).

[3] Kenneth Anger, *Hollywood Babylon* (New York: Dell, 1975), 89ff.

[4] See Giovanna Franci, Rosella Mangaroni, and Ester Zago, *The Other Shore of Byzantium or the Imagination of America* (Ravenna: Longo, 1992).

[5] Alide Cagidemetrio, *Una Strada nel Bosco: Scrittura e coscienza in D. Barnes* (Firenze: Neri Pozza, 1979), 14.

[6] See Steven Watson, *The Harlem Renaissance: Hub of African-American Culture, 1920-1939* (New York: Pantheon Books, 1995).

[7] Naturally, this argument would merit a long discussion. We limit ourselves to brief comments on two or three of the trademark names of the period. Paul Poiret was a true fashion revolutionary. After working for a period of time in the orientalizing Belle Epoque style, he made a name for himself in the twenties, becoming a fashion leader as the director of the *La Gazette du Bon Ton*. He worked with another famous Paul, Paul Iribe, designer of Deco jewelry and accessories, as well as furniture and clothing for Hollywood movies. But by unanimous consent, the uncontested queen of fashion was Coco Chanel. By the late twenties, the cachet of her designs, which were more in keeping with the functional tendencies of the time, had overshadowed Poiret. A separate and endlessly fascinating area is that of movie costume design. See, for example, the richly illustrated book *Hollywood Costume Design* by David Chierichetti. And to bring the matter up to date, we should cite two recent events: *Adrian, The Couture Years, 1942-52*, at the Los Angeles County Museum of Art at the end of 1995, and the Florence *Biennale*, which opened in September 1996.

[8] From an essay on Cassandre by Henri Mouron, *Baseline*, issue 10, quoted in Lewis Blackwell, *Twentieth-Century Type* (New York: Rizzoli, 1992), 96.

[9] Alastair Duncan, *American Art Deco* (New York: Harry N. Abrams, 1986), 20, quoting from *The Decorative Furnisher*, May 1925, 81.

[10] It should however be emphasized that during the twenties and thirties, especially in the big cities of the East Coast, that which is today defined as Deco referred almost exclusively to decorative detail, rather than to the design of entire buildings. It is not by chance that attention was focused primarily on the "decoration" of portals, entryways, lobbies, and facades, that is, on the "public face" of the buildings. The situation is different for private homes of the thirties and the forties, which were closer to the International Style, and for the case of Miami Beach, which created a harmonious unity of interior and exterior, structure and décor.

[11] *An International Exposition of Art in Industry*, Exhibition Catalog (R.H. Macy & Co., 1928), 8, cited in Duncan, *American Art Deco*, 24 n. 20.

[12] Gio Ponti, "Lo Stile Moderno fuori di Casa," *Domus* (May 1929): 29ff., cited in Rossana Bossaglia, *L'Art déco*, 130.

[13] Mary Fenton Roberts, "Beauty Combined with Convenience in some Modernistic Rooms," *Arts and Decoration* (February 1929): 112, cited in Duncan, *American Art Deco*, 43 n. 27.

[14] Barbara Capitman, Michael D. Kinerk, and Dennis W. Wilhelm, *Rediscovering Art Deco U.S.A.* (New York: Viking, 1994), 79.

[15] See Richard Neutra, *Survival through Design* (New York: Oxford, 1954), 53ff., 81ff.

[16] Erich Mendelsohn, *Amerika, das Bilderbuch eines Architekten* (Berlin, Rudolph Mosse Buchverlag, 1926), vi.

[17] Le Corbusier, *Quand les cathédrales etaient blanches* (Paris: Plan, 1937), cited in Maffioletti, *New York*, 11.

[18] See Guy Gauthier, *Villes imaginaires* (Paris: Cedic, 1977).

[19] See Hugh Ferriss, *The Metropolis of Tomorrow* (New York: I. Washburn, 1929).

[20] Ralph Flint, "In the World of Architecture," *The Art News* (October 31, 1925), 10, cited in Duncan, *American Art Deco*, 10 n. 5.

[21] Frank Lloyd Wright, "The Tyranny of the Skyscraper," *Creative Art*, 8 (1931): 332.

[22] Further discussion on the use of the terms 'modern' and 'modernistic' can be found in the Introduction to the volume by S. Heller and L. Fili, *Streamline. American Art Deco Graphic Design*, (S. Francisco, Chronicle Books, 1995); and in the Preface to the interesting catalog of the Wolfsonian (Miami Beach), *Designing Modernity* (New York, Thames and Hudson, 1995). Here the concept of modernity, mainly in the thirties, combines the aesthetic aspect with the political propaganda.

[23] Philip N. Youtz, "Architecture Revolts from Education," *The American Magazine of Art* 23, no. 4 (1931): 320.

[24] Cited in Bossaglia, *L'Art déco*, 131, n. 14.

[25] Lewis Mumford, "Two Chicago Fairs, *The New Republic*, 65 (January 21, 1931), 271, cited in Pokinski, *Development*, 1.

[26] See Marjorie Ingle, *Mayan Revival Style: Art Deco Mayan Fantasy* (Salt Lake City, UT: Gibbs M. Smith, 1984). Ingle points out that the style in question borrowed "from all cultures of Mexico and Guatemala, predominantly the Mayas, Aztecs, Totlecs, and Mixtecs," and that the term Mayan Revival is "a general term for all pre-Columbian or Mesoamerican influences on the arts and architecture." (vi)

[27] To Mitchell Wolfson Jr., bright collector and aficionado of early twentieth century art and Art Deco, we owe the precious Wolfsonian Foundation in Miami Beach. The Italian branch of the Wolfsonian in Genoa will be hosted in the newly restored Castello Mackenzie. Again, Art Deco travels from one shore to the other.

[28] For a carefully drawn distinction between Art Deco and Streamline Moderne in the United States, see David Gebhard, *The National Trust Guide to Art Deco in America* (New York: John Wiley and Sons, 1996).

[29] Beth Dunlop, *Building a Dream: The Art of Disney Architecture* (New York: Harry N. Abrams, 1996), and the catalog brochure for the

Biennale, Venice, 15 Sept-17 Nov. 1996, "La fabbrica dei sogni. L'arte dell'architettura Disney".

[30] Capitman et al., *Rediscovering Art Deco*, 59.

[31] Quoted in Reinhart Wolf, *New York in Photographs* (New York: Vendome Press; distributed by Viking Press, 1981), unpaginated.

[32] Harvey W. Corbett, "The American Radiator Building," *Architectural Record* 55 (1924), 477.

[33] See Donald M. Reynolds, *The Architecture of New York City* (New York: J. Wiley and Sons, 1994), 303ff.

[34] Walter Karp, *The Center: A History and Guide to Rockefeller Center* (New York: American Heritage, 1982), 72.

[35] John Mead Howells, "Vertical or Horizontal Design," *Architectural Forum* 52 (1930): 782, cited in Maffioletti, *New York*, 82.

[36] Vitrolite was the brand name of a glass-based material, also known as Carrara glass, which was manufactured in a variety of colors and was popular among Deco designers.

[37] Ely Jacques Kahn, "On the Use of Color," in *Ely Jacques Kahn*, ed. A.

T. North (New York and London: Whittlesey House, McGraw-Hill, 1931), 24.

[38] "The Arizona Biltmore: Refurbishing a Wrightian Legend in Phoenix," *Architectural Digest*, 53,3 (March 1996), 137.

[39] Some scholars in fact argue that Wright was the real architect of the project. See, e.g., Meryle Secrest, *Frank Lloyd Wright* (New York: Alfred A. Knopf, 1992), 350-354.

[40] See generally, T. William Booth and William H. Wilson, *Carl F. Gould: A Life in Architecture and the Arts* (Seattle: Washington University Press, 1995).

[41] See Ben Hall, *The Best Remaining Seats* (New York: Clarkson N. Potter, 1961), 212.

[42] John Kobal, *Gottasing Gottadance: A History of Movie Musicals* (London and New York: Hamlyn, 1971).

[43] Barbara Baer Capitman, *Deco Delights: Preserving the Beauty and Joy of Miami Beach Architecture* (New York: E.P. Dutton, 1988), 16.

List of color illustrations

Bibliography

Alpern, John, *New York. An Architectural Portfolio,* New York, Dutton, 1978.

Anger, Kenneth, *Hollywood Babylon,* New York, A Dell Book, 1975.

Arwas, Victor, *Art Deco,* New York, Harry N. Abrams, 1980.

Balfour, Alan, *Rockefeller Center. Architecture as Theater,* New York, McGraw-Hill, 1978.

Barnes, Djuna, *Nightwood,* Normal, Ill., Dalkey Archive Press, 1995.

Baudrillard, Jean, *America,* London, Verso, 1988; (*Amérique,* Paris, Grasset, 1986).

Bayer, Patricia, *Art Deco Architecture,* New York, Harry N. Abrams, 1992.

___, *Art Deco Source Book,* Oxford U.P., 1988.

Blackwell Louis, *Twentieth Century Type,* New York, Rizzoli, 1992.

Bluestone, Daniel M., *Constructing Chicago,* Yale U.P., 1991.

Bode, Carl, ed., *American Perspectives: The United States in the Modern Age,* Washington, D.C., USIA, 1990.

Booth, T.William and Wilson, H.William, *Carl F. Gould. A Life in Architecture and the Arts,* Washington U.P., 1995.

Bossaglia, Rossana, *Il Déco Italiano. Fisionomia dello stile 1925 in Italia,* Milano, Rizzoli, 1975.

___, *Guida all'Architettura Moderna. L'Art Déco, Bari, Laterza, 1984.*

___, *L'Art Déco,* Bari: Laterza, 1984.

Breeze, Carla, *L.A. Deco,* New York, Rizzoli, 1991.

___, *New York Deco,* New York, Rizzoli, 1993.

Cabanne, P., *Encyclopédie Art Déco,* Paris, Somogy, 1989.

Cagidemetrio, Alide, *Una strada nel bosco. Scrittura e coscienza in D.Barnes,* Vicenza, Neri Pozza, 1979.

Capitman, B., Kinerk, M. D., Wilhelm, D. W., *Rediscovering Art Deco U.S.A,* New York, Viking, 1994.

Capitman, Baer Barbara, *Deco Delights: Preserving the Beauty and Joy of Miami Beach,* New York, Dutton, 1988.

Carter, Randolph and Cole, R.Reed, *Joseph Urban: Architecture, Theatre, Opera, Film,* New York, Abbeville Press, 1992.

Cerwinske, Laura, *Tropical Deco,* New York, Rizzoli, 1981.

Charyn, Jerome, *Movieland,* New York, Putnam's Sons, 1989.

Chierichetti, David, *Hollywood Costume Design,* New York, Harmony Books, 1976.

Colombo, Furio, *La città profonda,* Milano, Feltrinelli, 1992.

Conrad, Peter, *The Art of the City. Views and Versions of New York,* New York, Oxford U.P., 1984.

Donati, Annalisa and Aslan, Sissi, *Dalla `Belle Epoque' allo stile aerodinamico,* Firenze, Giunti, 1992.

Duncan, Alastair, *American Art Deco,* New York, Harry N. Abrams, 1986.

___, *Art Deco,* London, Thames and Hudson, 1988.

___, (ed.) *The Encyclopedia of Art Deco,* New York, E.P. Dutton, 1988.

Dunlop, Beth, *Building a Dream: The Art of Disney Architecture,* New York, Harry N.Abrams, 1996.

___, ed., *La fabbrica dei sogni. L'arte dell'architettura Disney,* Introduction to "Una mostra alla Biennale di Venezia", 15 Sept.-17 Nov. 1996.

Encyclopédie des Arts Décoratifs et Industriels Modernes au XXe siecle, 12 Volumes, Paris, Office Central d'Editions et de Librairie, 1925.(Reprint, New York, Garland, 1977).

Etter, Don D., *Denver Going Modern,* Denver, Graphic Impressions Inc., 1977.

Ferris, Hugh, *The Metropolis of Tomorrow,* New York, Ives Washburn, 1929.

Finler, Joel W., *Hollywood Movie Stills. The Golden Age,* Londn, Batsford, 1995.

Fitzgerald, Francis Scott, *The Great Gatsby,*(1925) New York, C.Scribner's Sons, 1953, (Introduction by Fernanda Pivano to the Italian edition, *Il grande Gatsby,* Milano, Mondadori, 1972).

___, *The Crack-up,* New York, New Directions, 1945 (It. ed., *L`eta del Jazz e altri scritti,* Milano, Garzanti, 1976, Preface by Elémire Zolla).

Franci, G., Mangaroni, R., Zago, E., *The Other Shore of Byzantium, or the Imagination of America (L`altra sponda di Bisanzio, ovvero l`immaginazione dell`America),* Ravenna, Longo, 1992.

Gates, Robert A., *The New York Vision: Interpretations of New York City in the American Novel,* Boston, America U. P., 1987.

Gauthier, Guy, *Villes Imaginaires,* Paris, Cédic, 1977.

Gebhard, David, *Schindler,* New York, The Viking Press, 1971.

___,*Streamline Los Angeles,* Los Angeles, Conservancy, 1984.

___,*The National Trust Guide to Art Deco in America,* New York, John Wiley and Sons, 1996.

Gebhard, D. and Winter, R., *Architecture in Los Angeles. A Complete Guide,* Salt Lake City, Peregrine Smith, 1985.

Green, Stanley, *The World of Musical Comedy,* New York, A Da Capo Paperback, 1980.

Hanks, David, *Donald Deskey: Decorative Designs and Interiors,* New York, 1986.

Harmon, Robert B., *The Art Deco Style in American Architecture: A Brief Style Guide,* Monticello, Ill., Vance Bibliographies, 1983.

Hatton, Hap, *Tropical Splendor: An Architectural History of Florida,* New York, Alfred A.Knopf, 1987.

Heller, Steven and Fili, Louise, *Streamline: American Art Deco Graphic Design,* San Francisco, Chronicle Books, 1995.

___, *Italian Art Deco,* San Francisco, Chronicle Books, 1993.

Hillier, Bevis, *Art Deco of the 20s and 30s,* London, The Herbert Press, 1968.

Hines, Thomas, *Richard Neutra and the Search for Modern Architecture,* New York, Oxford U.P.,1982

Hitchcock, Jr, Henry-Russell and Johnson, Philip, *The International Style,* New York and London, (1932) 1966.

Hitchcock, Jr, Henry-Russell, *Modern Architecture: Romanticism and Reintegration,* New York, Payson & Clarke, 1929.

Horsham, Michael, *20' and 30's Style,* London, Grange, 1989.

Ingle, Marjorie, *Mayan Revival Style: Art Deco Mayan Fantasy,* Salt Lake City, UT, Gibbs M.Smith, 1984.

Kaplan, Wendy, ed., *Designing Modernity. The Arts of Reform and Persuasion, 1885-1945,* New York, Thames and Hudson, 1995.

Karp, Walter, *The Center: A History and Guide to Rockefeller Center,* New York, American Heritage, 1982.

Kery Frantz, Patricia, *Graphic Art Deco,* New York and London,

Balance House Ltd., 1986.

Klein, Dan, *All Color Book of Art Deco,* London, Octopus, 1974.

Klein, McLelland, Haslan, *In the Deco Style,* New York, Rizzoli,1986.

Kobal, John, *Gottasing Gottadance. A Pictorial History of Film Musical,* London-New York, Hamlyn, 1971.

La Polla, Franco, *Sogno e Realtà nel Cinema di Hollywood,* Bari, Laterza, 1987.

Lawrence, Attila, "Postmodern Moods of Art Deco", in *Popular Culture Review,* vol.4, n.1, 1993, University of Nevada.

Maffioletti, Serena, *New York. Un secolo di Grattacieli a Manhattan,* Milano, CLUP, 1990.

Massobrio, G. e Portoghesi. P., *Album degli Anni Venti,* Bari, Laterza, 1976.

Mueller, John, *Astaire Dancing. The Musical Films,* New York, Wings Books, 1985.

Nacache, Jacqueline, *Lubitsch,* Paris, Edilig, 1987.

Neutra, Richard, *Survival through Design,* New York, Oxford U.P., 1954.

Noel, Thomas J. and Norgren, Barbara, *Denver: The City Beautiful and its Architects, 1893-1941,* Denver, CO, Historic Denver Inc.,1987.

Ochsner, Jeffrey K., ed., *Shaping Seattle Architecture: a Historical Guide to the Architects,* Seattle and London, Washington U.P. in association with the American Institute of Architects Seattle Chapter and the Seattle Architectural Foundation, 1994.

Ostergard, Derek, *Art Deco,* New York, Hugh Lanter Levin Assoc. Inc., 1991.

Peary, Danny, *Alternate Oscars,* New York, Simon and Schuster, 1993.

Pokinski, Deborah F., *The Development of the American Modern Style,* Ann Arbor, Michigan, UMI Research Press, 1984.

Poague, Leland A., *The Cinema of Ernst Lubitsch,* Cranbury, N.J., Barnes and Co., 1978.

Pruzzo, Piero, *Musical Americano in Cento Film,* Genova, Le Mani, 1995.

Reynolds, Donald M., *The Architecture of New York City,* New York, J. Wiley and Sons, 1994.

Robinson, Cervin and Rosemarie Haag Bletter, *Skyscraper Style: Art Deco New York,* N.Y., Oxford U.P., 1975.

Robinson, Julian, *Splendeurs de l'Art Déco,* Paris, Vilot, 1990.

Rubin, Martin, *Showstoppers. Busby Berkeley and the Tradition of Spectacle,* New York, Columbia U. P., 1993.

Scully, Vincent Jr., *Modern Architecture,* New York, G. Braziller, 1961.

Secrest, Meryle, *Frank Lloyd Wright,* New York, Alfred A.Knopf, 1992.

Sennett, Ted. *Great Hollywood Movies,* New York, Abredale Books/Harry N. Abrams, 1983.

Sinkevitch, Alice, ed., *AIA Guide to Chicago,* San Diego, Harcourt Brace and Co., 1993.

Sklar, Robert, *Movie-made America. A Cultural History of American Movies,* New York, Vintage Books, 1994 (reprint of 1975).

Smith, Kathryn, *Frank Lloyd Wright, Hollyhock House and Olive Hill: Buildings and Projects for Aline Barnsdall,* New York, Rizzoli, 1992.

Socci Stefano, *Fritz Lang,* Milano, Il Castoro, 1994.

Starr, Kevin, *Material Dreams. Southern California Through the 1920`s,* New York and Oxford, Oxford U.P., 1990.

Stern, Robert A. M.; Gilmartin, Gregory; Mellins, Thomas, *New York 1930. Architecture and Urbanism between the two World Wars,* New York, Rizzoli International Pub., 1987.

Stones, Barbara, *America goes to the Movies,* North Hollywood, National Assoc. of Theater Owners, 1993.

Van de Lemme, A. *Guida allo Stile Art Deco,* Novara, De Agostini, 1987.

Venturi, Robert, Scott Brown, Denise, Izenour, Steven, *Learning from Las Vegas,* Cambridge, Harvard U. P., 1977.

Veronesi, Giulia, *Style and Design 1909-1929,* New York, George Braziller, 1968.

Vlack, Don, *Art Deco Architecture in New York: 1920-1940,* New York, Harper and Row, 1974.

Watson, Steven, *The Harlem Renaissance. Hub of African-American Culture, 1920-1939,* New York, Pantheon Books, 1995.

Willensky, Elliott and White, Norval, *AIA Guide to New York,* New York, Harcourt Brace Publ., 1988.

Wilson, Richard Grey·and Robinson, Sidney K., eds., *Modern Architecture in America. Visions and Revisions,* Ames, Iowa State U. P., 1991.

Wolf, Reinhart, *New York in Photographs,* New York, Vendome Press, distributed by Viking Press, 1981.

Zukowsky, John, ed., *Chicago Architecture and Design, 1823-1993. Reconfiguration of an ___, American Metropolis,* Munich, Prestel-Verlag and The Art Institute of Chicago, 1993.

Contributors' notes

Giovanna Franci teaches English Literature at the University of Bologna. She has written on the Gothic Novel (*La messa in scena del terrore*, Ravenna, 1982), on Romantic poetry (ed. of *Blake. Mito e linguaggio*, Pordenone, 1983), on "fin-de-siècle" literature (*Il sistema del Dandy. Wilde, Beardsley, Beerbohm*, Bologna, 1977), and on women's romance. She has written extensively on the myth of the Vampire, on the theory of the Sublime, on the image of the city in the age of Multiculturalism, and on contemporary literary criticism, from Deconstruction to New- Historicism. Together with Vita Fortunati, she is the editor of the *Krinein* series, published by Mucchi, Modena; and together with Vita Fortunati and Alfredo De Paz, she is the editor of the series *Romanticismo e dintorni*, published by Liguori, Naples.

Rosella Mangaroni lives in Bologna. She taught humanities in a high school. Together with Adriana Flamigni, she has written three biographies on Foscolo (1987), on Ariosto (1989) and on Campanella (1995), published by Camunia, Milan. Together with Giovanna Franci, she has translated into Italian, with a critical introduction, *The Vampire* by J. W. Polidori (1984), *Hieroglyphic Tales* by H. Walpole (1986) and *Turkish Tales* by G. Byron (1988), published by Studio Tesi, Pordenone. At present she is working on women's romance and American *soap opera*. Together with V. Fortunati and G. Franci she has edited a book on this subject *Maestre d'amore. Eroine e scrittrici del rosa inglese* (Bari, 1986).

Esther Zago teaches in the Honors Program at the University of Colorado at Boulder. A comparatist by training, she has investigated, in numerous essays, the evolution of fairy tales from the Middle Ages to Perrault, Basile, and Calvino. With Giovanna Franci she has authored *La bella addormentata. Genesi e metamorfosi di una fiaba* (Bari, Dedalo, 1984), and, again with G. Franci, she has published the Italian edition of H. Walpole's *Essay on the Modern Garden* (Firenze, Le Lettere, 1991). Her work in progress includes a social study of medieval Aesopic fables, and an anthology of American writings on Romanticism with G. Franci and J. Robinson.

G. Franci, R. Mangaroni and E. Zago have co-authored a bilingual monograph, *The Other Shore of Byzantium, or the Imagination of America* (*L'altra sponda di Bisanzio, ovvero l'immaginazione dell'America*), published by Longo, Ravenna, 1992, with photographs by **Federico Zignani.**

Federico Zignani, born in Bologna, has studied at the Brooks Institute of Photography (Santa Barbara, California), and worked at "Studio Casadei" in Bologna, from 1988 to 1990. At present he is working as a freelance photographer between Los Angeles and Italy, where he lives. He has been responsible for the photographic section of the volumes AAVV, *Maestre d'amore* (Bari, 1986) and H. Walpole, *Strawberry Hill* (Palermo, 1990). He is the photographer of the volume *The Other Shore of Byzantium, or the Imagination of America*, (Ravenna, 1992). Exhibitions of his photographs from the Byzantium volume were held in Cattolica (March 1993), at the Centro Culturale Polivalente, and in Chicago (April 1993), at the Italian Institute of Culture.